759.2 SHE

759.2 SHE

Painting with DAVID SHEPHERD

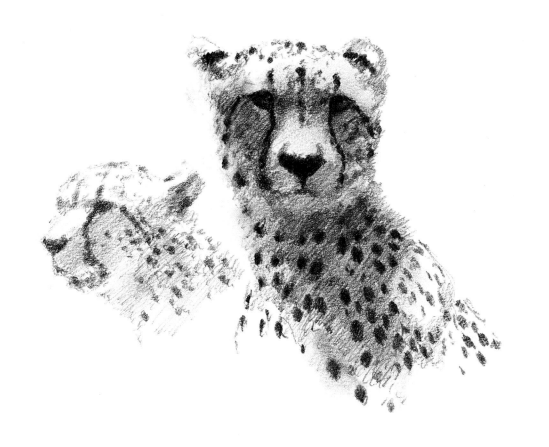

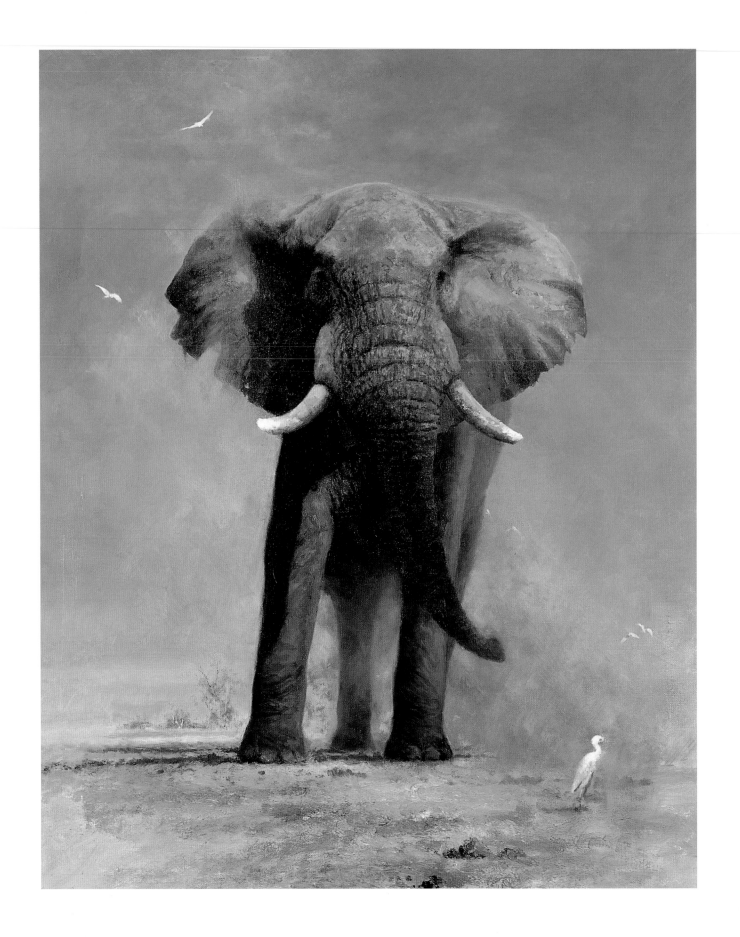

Painting with DAVID SHEPHERD

HIS UNIQUE STUDIO SECRETS REVEALED

David Shepherd

with

Brenda Howley

To the elephants that have brought me all my success

First published in 2004 by
Collins, an imprint of
HarperCollins*Publishers*
77-85 Fulham Palace Road
Hammersmith, London W6 8JB

The Collins website address is www.collins.co.uk

Collins is a registered trademark of HarperCollins Publishers Ltd

10	09	08	07	06	05	04
7	6	5	4	3	2	1

A catalogue record for this book is available from the British Library

ISBN 0 00 715772 X

Colour reproduction by Colourscan, Singapore
Printed and bound by Imago, Hong Kong

AUTHOR'S NOTE:
No discourtesy is intended if the ownership of some paintings is not
acknowledged. It is simply that over the years many of my pictures
have changed hands and I no longer know where they are. I feel that
it is most appropriate, therefore, to thank everyone and I hope that
you are not too surprised if you discover your painting reproduced
in this book.

page 2
My Savuti Friend
Oil on canvas
71 x 56 cm (28 x 22 in)

CONTENTS

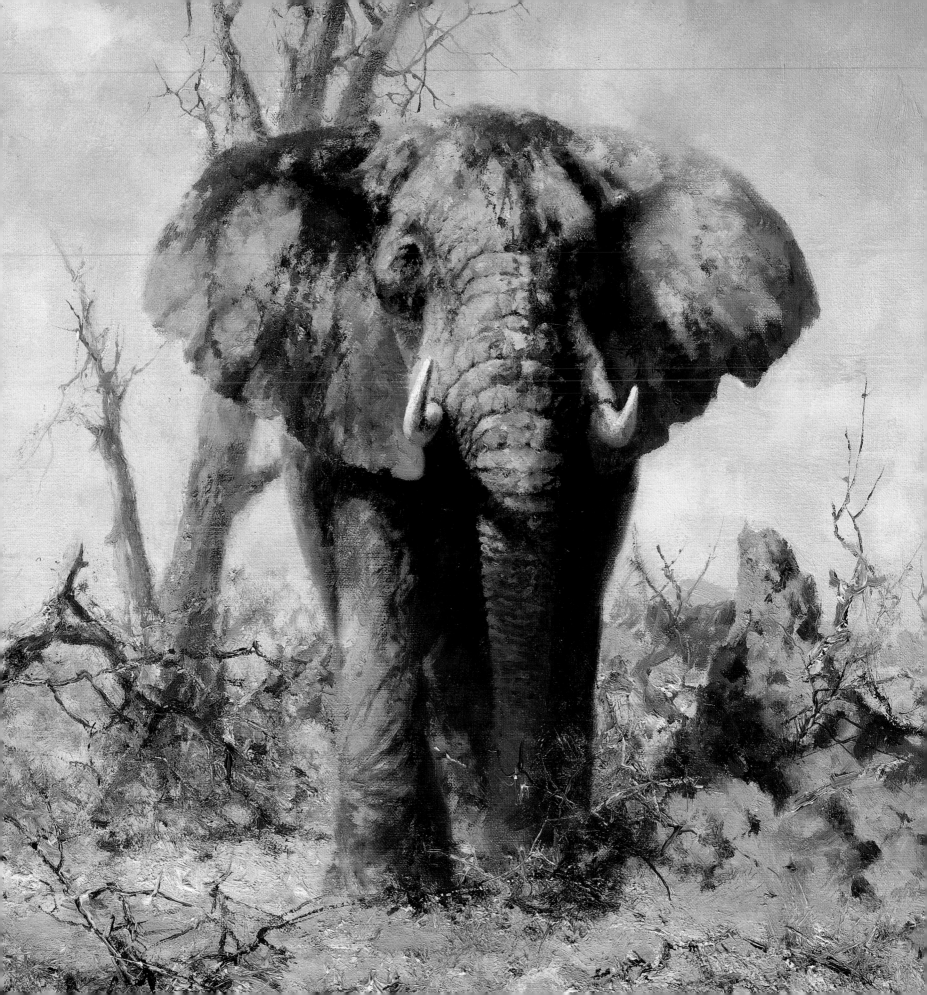

INTRODUCTION

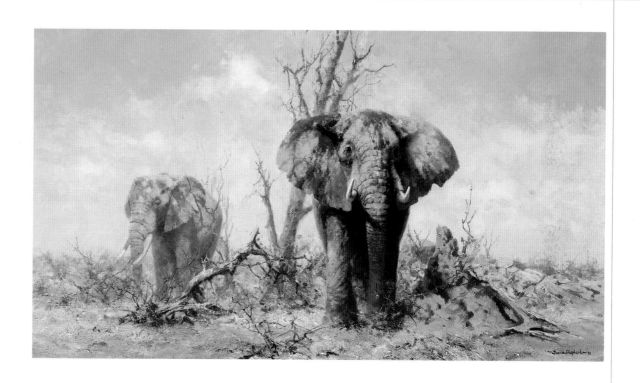

PAINTING WITH DAVID SHEPHERD

To paint like David Shepherd, you have to throw the conventional rules of oil painting out of the 4 x 4 safari truck window and go with the flow. If you're happier sticking to prescribed tried and tested techniques, you can bail out now – or fasten your seat belt for a breath-taking painting adventure.

Forget forward planning. Leave behind all those lessons you've been taught about the rights and wrongs of oil painting.

David Shepherd views each new painting as a journey and he tackles it with the same spirit of adventure he felt the first time he put brush to canvas. He's never quite sure if he'll reach his destination – and neither are you. But somehow you get there. And the end result is always exhilarating.

There may be similarities in his choice of subject matter, but there's nothing jaded or mechanical about the way he works. Every elephant, every lion, every subject he paints is unique, and he approaches each one with a fresh eye, endowing it with its own character.

Having prepared a preliminary sketch, whether it's for a new painting of a buffalo or a blacksmith's forge, he'll reject it if the character or the scene it portrays doesn't fit the spirit of the painting that starts to grow with each stroke of the brush. An animal that looks too aggressive or too friendly, or a composition sketched out in charcoal that doesn't work can also be summarily rejected in favour of a more sympathetic alternative.

David Shepherd's rare sensitivity to the nature and essence of his subjects marks him out as a painter of outstanding talent. This is the first time that he has opened his studio and invited artists of all levels to share his painting secrets. The result is a unique chance to join him on an exciting (and sometimes scary) artistic safari.

Brenda Howley, coauthor
August 2004

previous spread
Muddy Jumbo
Oil on canvas
51 × 89 cm (20 × 35 in)

Painting mud is a lovely experience, as it gives the artist the opportunity to use an infinite variety of colours.

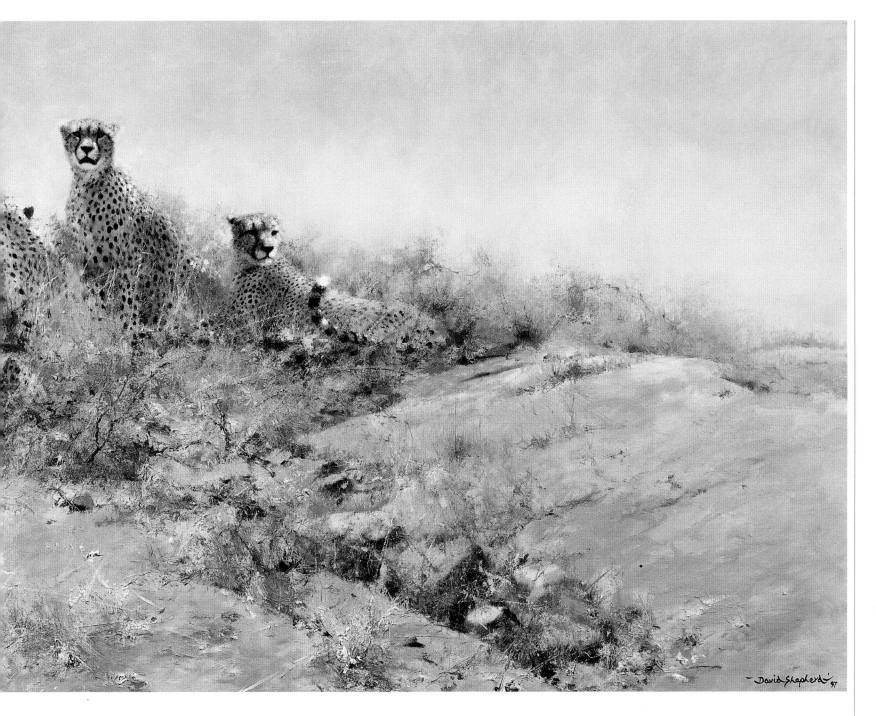

The Cheetahs of Namibia
Oil on canvas
71 × 102 cm (28 × 40 in)

In this painting the four cheetahs are in fact the same animal,
painted in different poses. If a wildlife photographer hoped to
get a group of cheetahs together in such a striking composition
he would have to wait a lifetime!

MY PAINTING LIFE

Some people believe that to become a professional artist you need natural talent. I'm the first to admit that I had none. Anyone who sees my first attempt at an oil painting, *Seagulls*, will agree. I am living proof that a person with enough determination can, in fact, be taught to paint.

When I submitted it with my application to join the Slade School of Art, they described it as 'a painting of birds of dubious ancestry, flying in anatomically impossible positions over a lavatorial green sea.' I couldn't have put it better myself!

I'd already failed to get the job I really wanted – as a game warden in Kenya. Now it seemed I had little hope of becoming an artist either.

It was at this point in my life when a chance meeting at a party with professional artist Robin Goodwin changed my life forever. He wasn't keen to take on a student but he agreed to look at my ill-fated bird painting. He must have regarded me as a challenge, or maybe it was pity, but he did agree to teach me.

Over the next three gruelling years, he warned me, he would never say anything good about my work. He'd assume I already knew the good things, so he would tell me only about the bad things. It was a tough training, but it taught me as much about discipline as it did about art. I have nothing but praise for him. I owe him everything.

I was terrified the first time he took me out painting in the streets of London, but it proved a good grounding for working outdoors in the most difficult conditions. The very first painting I sold, on the Embankment in London, was a small English landscape priced at £25. The buyer haggled me down, pound by pound, until I gave in and settled for £12. I had to carry the picture to his car, which turned out to be a Rolls Royce – complete with chauffeur. I swore I'd never be beaten down like that again. Even struggling artists should recognize their own worth.

I did my first wildlife painting in Kenya. I'd gone out there as an aircraft artist but the station commander at Eastleigh near Nairobi wanted a couple of wildlife pictures for the Officers' Mess. Until then I'd never thought about painting animals, but I had a go. My first attempt was a rhino chasing an RAF plane off a landing strip. They bought it, I returned home and my career took off. Two years later, in 1962, I had a wildlife exhibition in London and the whole lot sold in the first 20 minutes.

The same year I painted *Wise Old Elephant* and it was published as a fine art print. I couldn't imagine it would sell well enough to cover the costs – which shows how wrong you can be. Over the next 25 years 'the elephant in Boots' sold an estimated 250,000 copies. You're probably thinking I made a packet out of it, but in fact I'd sold the copyright for just £100.

My painting life, with all its successes and struggles, has brought me many marvellous adventures. I hope you enjoy this practical insight into my studio secrets, as well as the stories of my career and travels.

David Shepherd
August 2004

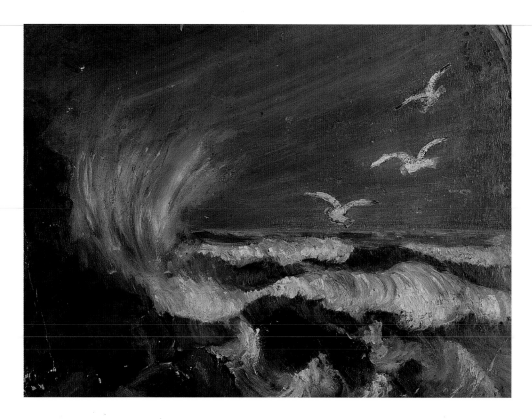

Seagulls
Oil on board
46 × 58.5 cm (18 × 23 in)

Robin Goodwin
Oil on canvas
35.5 × 46 cm (14 × 18 in)

This is the man to whom I owe everything. It was a love-hate relationship. He was beastly to me but that was his way of instilling discipline and we had enormous fun working together. If I hadn't met him, I would be driving a bus.

CONSERVATION MATTERS

It was the devastating sight of 255 zebra lying dead by a waterhole, poisoned by poachers with battery acid, which turned me into a conservationist. That was more than 40 years ago, long before the realization that we must stop destroying our planet had become common currency.

Sadly, despite increased awareness of the dangers we are imposing on the earth, I believe the human race is sitting on a time bomb. Time is running out for many creatures – every hour another species becomes extinct. If we don't change our arrogant assumption that we own the world and can use it to our own advantage, there can be no future for us or the rich variety of animals who share this planet.

When I set up The David Shepherd Wildlife Foundation (DSWF) I was determined it should remain flexible and non-bureaucratic. Being a practical person, I wanted to feel we could make a real difference. With that in mind, we support particular projects with immediate, practical help. It's the least I can do. I owe all my success to the animals I paint, and I'm passionate about their continued survival.

Since we started, we have given away over £3 million in grants, supporting a range of innovative and far-reaching projects throughout Africa and Asia. We send undercover agents into the field to investigate wildlife crime, train and supply anti-poaching patrols, establish nature reserves and other protected areas, and work with governments to establish conservation laws. We also try to educate people of all ages about the plight of animals threatened by the destruction of their habitat, hunting, poaching and pollution.

Over the past few years we have trained and equipped every forest officer in India's famous Sunderbans Tiger Reserve, uncovered smuggling cartels in Zambia and seized thousands of pounds worth of illegal ivory, and reduced poaching in Russia, allowing Siberian tigers in the wild to increase from 100 to over 400 in number.

We have helped purchase land next to one of South Africa's National Parks, home to the last 800 surviving mountain zebra, extending the park by over 200 per cent and introducing black rhino after an absence of 150 years. Our Asian Conservation Awareness Programme, 'When the Buying Stops, The Killing Can Too', regularly reaches over 40 million homes across Asia and, with the support of film idol Jackie Chan and other international celebrities, has persuaded many to stop consuming wildlife. These are just some of the many projects we have been supporting around the world.

Current projects are detailed in our magazine *Wildlife Matters* and on our website. If you would like to support a particular initiative, let us know. We guarantee that 100 per cent of your donation will go to your chosen project.

By buying this book, you have already made a small contribution to our work. If you'd like to do more to help us to ensure that the wonderful animals we love to paint are not consigned to history, please contact DSWF.

Office & Trading Company based at:
61 Smithbrook Kilns
Cranleigh, Surrey GU6 8JJ
Tel: 01483 272323
Fax: 01483 272427

Email:
dswf@davidshepherd.org

Websites:
www.davidshepherd.org
www.artforsurvival.org

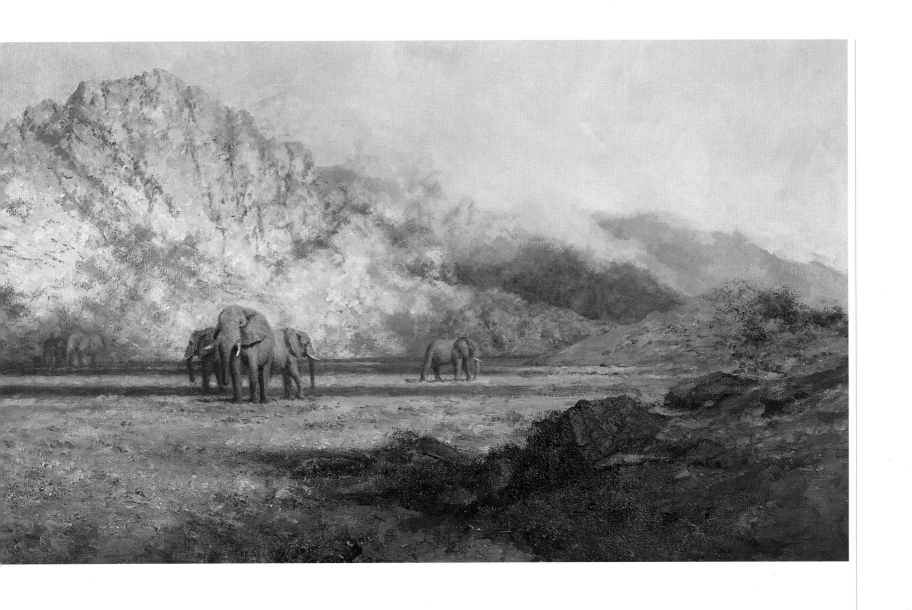

**A Namibian Landscape,
the Hoenib River**
Oil on canvas
51 × 109 cm (20 × 43 in)

It is almost impossible to find a perfect composition provided
by Nature but the artist has the freedom to move rocks around
to suit the design. However, in this case what you see in the
painting is what I saw. The only artistic licence I exercised was
to add the elephants to this spectacular landscape.

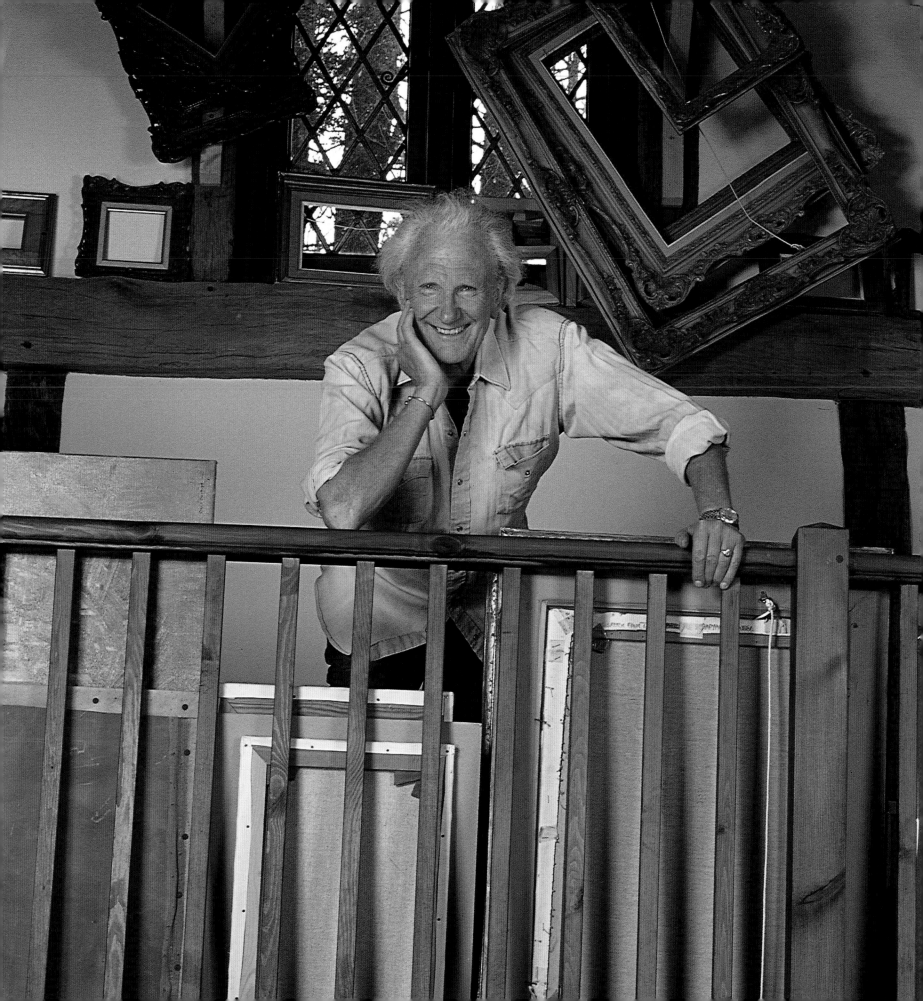

MATERIALS & METHODS

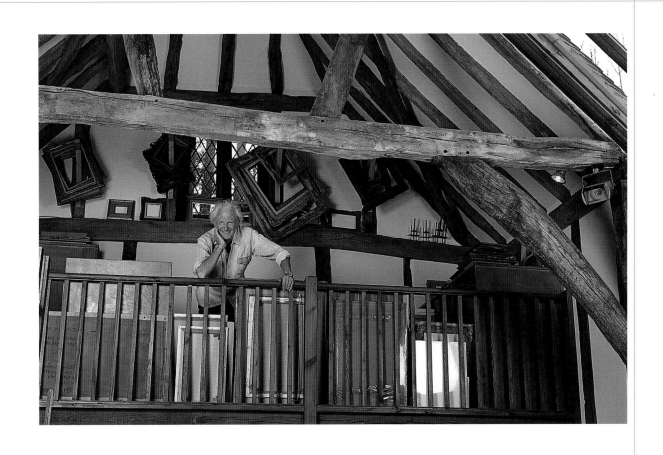

WHERE I PAINT

For much of my painting life, we lived in a rambling fifteenth-century farmhouse near Godalming in Surrey. There I worked in an Elizabethan barn, which I had brought in and rebuilt in the grounds.

I'm very conservative by nature, so when we moved to Sussex a few years ago, it was into another lovely old medieval farmhouse, this time smaller and less rambling. It had no studio, so I had another Elizabethan timber barn built in the garden. It was delivered in numbered pieces and erected on the spot. We also have a tunnel to get from the house to the studio because I don't like getting wet. All the locals think I'm mad.

I have always believed that I must paint every hour that God gives me and that every moment has to be lived to the full. I don't regard my painting as work and am miserable if I am not in my studio. I am lucky to have a long waiting list for commissions, so I may well have two paintings going at the same time. I cannot paint in silence; I may listen to a play or, even better, to music ranging from Frank Sinatra and Glen Miller to Rachmaninov and Gustav Mahler, my very favourite composer.

My day begins early, helping Julie, my personal assistant, with the office work. This often means that I do not get into my studio until around half-past nine. I always stop at half-past ten for a quick cup of tea and then return to the studio until lunchtime. I get cross if everything isn't exactly as I want it – it's a wonder my wife is still happily married to me after so many years! I am often out in the evenings, fundraising for my wildlife foundation and giving talk shows. Otherwise I paint until it gets dark.

We are lucky to have the chance to travel a lot, mainly for the wildlife foundation and, whenever possible, I love to work outdoors on location. When you're driving around, you never know when you're going to spot some interesting feature of the landscape that can be incorporated in a future painting, or spark an idea for a new subject.

When painting on location, however remote, you're likely to attract the attention of interested onlookers.

previous spread
The beautiful beams and minstrel gallery
of my Elizabethan barn studio.

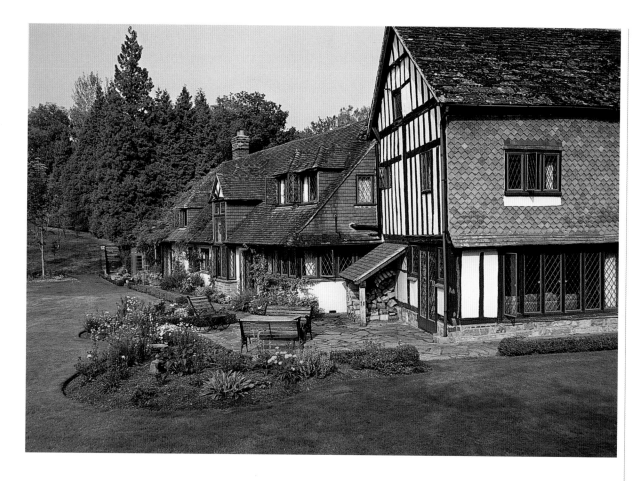

Brooklands Farm, the family
home in Sussex.

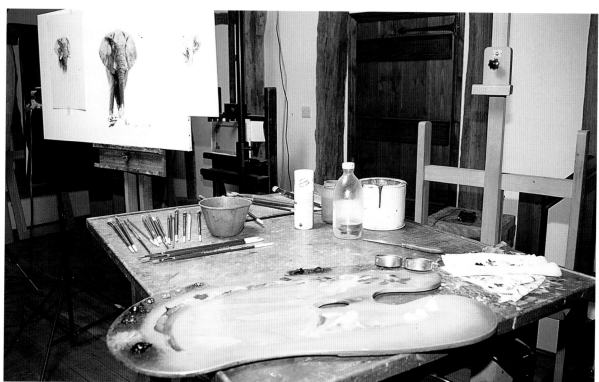

My painting table, with all the essentials
laid out, ready to start painting.

MY PAINTING MATERIALS

Oil colour is a wonderful medium for painting. I love its rich creamy consistency and the way you can manipulate it on the surface, adjusting and readjusting it until you get the effect you want. You can't do that with watercolour.

I've been using oil colour for more than 50 years, but it has never lost its appeal and I find it just as exciting today as I did the first time I picked up a brush and palette. If you've never tried it, I urge you to have a go. It's the most satisfying painting experience.

MY COLOURS

I've always used the same 16 colours, which I believe is known as an Old Master's palette. It does everything I want, whether that is painting the Arabian desert, an English landscape, an old steam train or a portrait. They're all Daler-Rowney Artists' Oil Colours, which I mix with linseed oil. I know most oil painters use turpentine to thin colour, but I only use it for cleaning the brushes and palette.

Some artists say you shouldn't use black, but I use a lot of Ivory Black. There are a number of whites on the market these days, but there's only one for me and that's Titanium White. It's the most powerful of all the whites, and I use it extensively throughout a painting, both to add body to colour mixes and, in its purest form, for the most intense highlights.

I don't use many tube greens, but I like Cadmium Green, and Olive Green is a useful muted colour. There are colours I wouldn't touch, such as Viridian. I believe it is much better to manufacture greens from the blues and yellows you have on your palette.

Raw Umber is a lovely cool brown. I use it diluted for drawing onto the canvas and add it to neutralize bright mixes when I need a subtler low key colour. When I want to mix a range of warm muted tawny colours I often use Light Red, a gentle red, if I feel that Cadmium Red would be too bright. Crimson Alizarin is another lovely red colour, but it is very strong and can easily

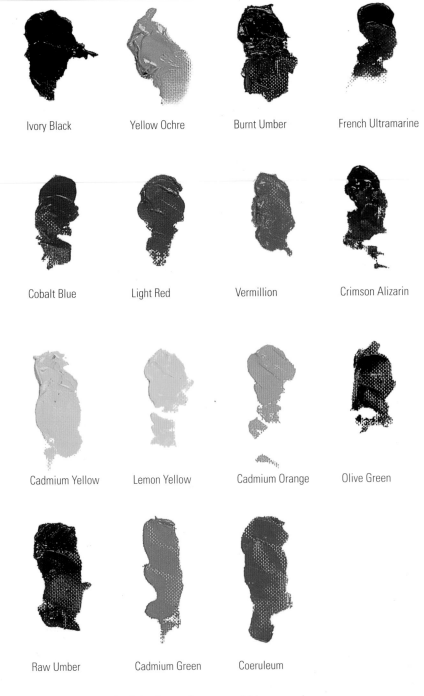

Ivory Black Yellow Ochre Burnt Umber French Ultramarine

Cobalt Blue Light Red Vermillion Crimson Alizarin

Cadmium Yellow Lemon Yellow Cadmium Orange Olive Green

Raw Umber Cadmium Green Coeruleum

overpower a mix. It's always best to add it a touch at a time until you have the colour you want.

I keep all my tubes of oil paint in use under my painting table. New ones are stored in the old wooden cabinet shown overleaf, which was originally used by British Rail to issue railway tickets. I managed to rescue this just as they were about to burn it.

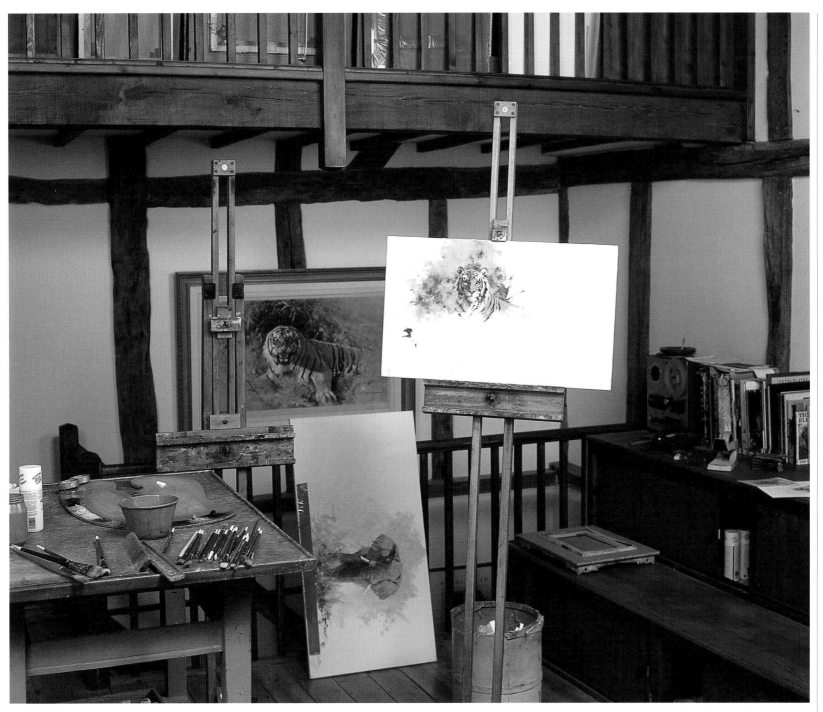

Inside the studio – the steps from the underground tunnel lead up into the corner.

MY PALETTE

In the 50 years I've been painting, I've only had two palettes, and I've made them both myself, from ordinary pale brown plywood. I was once given a very expensive mahogany palette but I found that the dark red base made it very difficult to judge tones.

I made both my palettes according to Robin Goodwin's instructions – with double thickness wood closest to one's arm. This means that the palette balances perfectly as one holds it.

When people see my palette, they are surprised at the strange order in which I arrange the colours. When I did my very first painting in 1948, I squeezed out the colours without any preconsidered design whatsoever and have followed the same format to this day.

When I have finished painting, I always clean the centre of my palette. Although just built of plywood, it now has a lovely neutral coloured patina and it will last the rest of my life.

My spare paint tubes are stored in this old British Rail ticket cabinet.

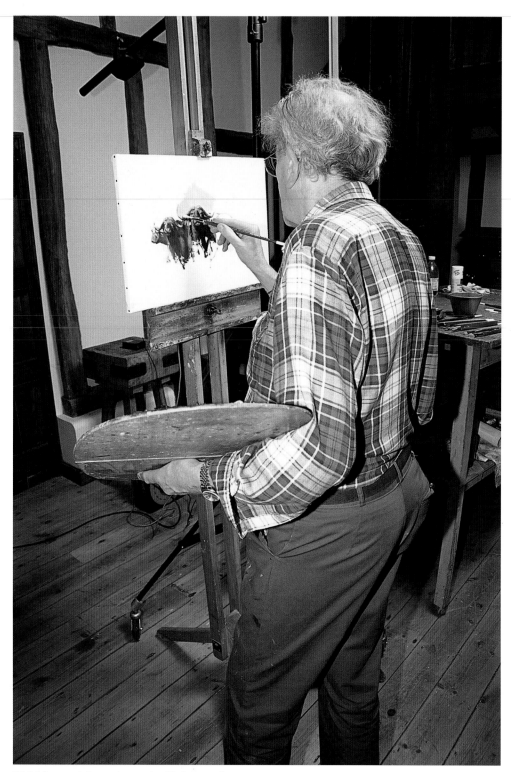

Weighting a palette creates a natural balance and allows greater comfort during long hours at the easel.

Painting with David Shepherd

OTHER MATERIALS

I use flat hog hair brushes as well as filberts and riggers in a variety of sizes. I am wicked to my brushes, as you will discover later in the book. They last for about four paintings because I bash them until the bristles splay out.

My canvases are always medium grained, ready-primed and stretched. I try to restrict painting to real sizes but this is getting harder. I tend to start a composition on a larger canvas than I need, and then have to take it off the stretcher and mount it on a smaller one. I never seem to learn!

I don't hang any paintings on my studio walls. Finished and half-finished canvases are always stacked facing the wall so I'm not distracted and my attention is focused on only the painting I'm working on.

When I am working on a commission, I take the painting almost to the finished stage and then put it against the wall for a couple of weeks. I can then look at it with a fresh eye and add a number of little touches which make the painting that much better. Invariably the painting is still wet when the client comes to collect it but no-one seems to mind.

USING A CAMERA

I enjoy nothing more than sketching from life, but taking photographs can be very effective, especially when time is short or the light is failing.

It's obviously also not practical to work from life when painting animals in oils. I did get away with it when painting *My Savuti Friend* (see page 2), sketching the elephant from a few yards away. However, it's not always safe to try it!

For years I've relied solely on sketches and photo prints, but I've recently started using a video camera. Filming animals on the move and using a freeze-frame function improves your understanding of a species and also helps you to get more movement into your wildlife paintings.

I prefer to use my own video footage shot on location but for those artists not able to film animals on the move, there are some marvellous wildlife programmes on television that you can record on video and use in the same way.

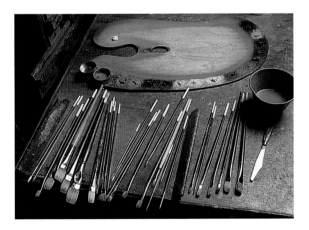

Hog brushes alongside my home-made plywood palette.

Paintings in progress are always turned to the wall to prevent me becoming distracted.

CLOSE-UP ON TECHNIQUE

Everything I know about painting, I learned from Robin Goodwin. He put me through a tough three years, but I remain eternally grateful to him for sharing his techniques.

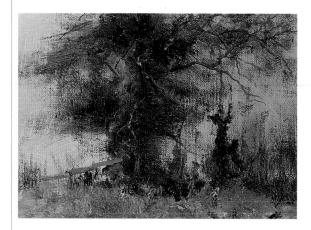

Blending on canvas

The beauty of oil paint is its rich juiciness that allows you to push the paint around on the surface. Used thickly, it produces wonderful textures. I often blend directly on the canvas for subtle effects that can't always be achieved by pre-mixing colour on the palette.

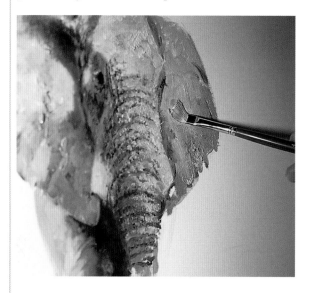

Colour within colour

When you're using a single brush, picking up different colours without cleaning it out each time, the bristles fill up with a variety of pigments. It's a question of judgement, angling the brush, pressing it onto the canvas and squeezing out the colour you want. Paint picked up earlier, which now lies deep in the bristles, may come through and that's a matter of practice. Colours within colours add surface interest and are often more effective than a solid block of single colour.

Painting to the bottom of the canvas

Slide a stick along the easel ledge behind the canvas, bringing it forward so it's flush with the front edge. Then you'll be able to take the paint all the way down to the bottom of the painting.

Broken lines

Oil colour, particularly Raw Umber, well diluted with linseed oil or turps 'cringes' when it hits the canvas, creating a fragmented effect. It's a great technique for painting fine twigs or blades of grass – try it.

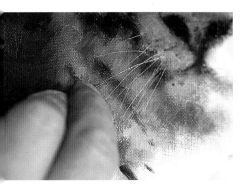

Whiskers and fine lines

The easiest way to paint whiskers is to scratch into wet paint using a household nail or the point of a pin, as I am doing in the picture on the left.

Be sure to work in the direction of growth, from the face outwards. Lessen the pressure as you reach the tip and you will create a fine, tapering line.

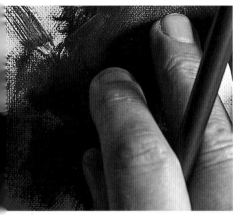

Finger painting

Smudging wet paint with your fingers is one of the best ways to blend colour on the surface and to soften hard edges. It's especially useful in wildlife painting to create a furry outline.

I prefer to use only linseed oil to make thin colour, spreading and thinning the colour on the canvas with my fingers.

This technique is also useful when you want to break the solidity of a background. A few areas dabbed with a finger when the background is still wet can create the effect of patchy sunlight coming through.

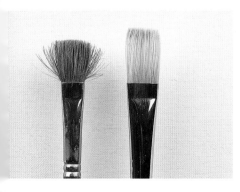

Sharp edges

Flat brushes don't last for more than four or five paintings before they lose their sharp chisel edge. It's worth making a regular investment in new brushes, rather than trying to work with those that are worn and blunted, like the one on the left in this photograph.

Brush-bashing

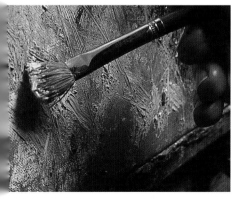

Bashing a hog brush against a leg or table top causes the bristles to splay out in all directions. Then, if it is touched lightly into a build-up of paint on the palette, such as yellow or green, each hair of the brush will pick up the colour. Quick movements with the hand will create useful effects, such as individual blades of grass or highly textured foreground scrub and thickets.

Cutting and joining

When I start a new work I can become so excited about the main subject that I begin painting this first. I often realize too late that it's in the wrong place, and end up painting over it and repainting it elsewhere.

If a picture is well-advanced when I need to reconsider the composition, I will literally crop the canvas, slicing a section off, or even cutting a portion out of the middle. It then has to go to a professional mender to be invisibly rejoined. It's not a technique I would recommend – more a necessary evil for a spontaneous painter who sometimes lets enthusiasm get the better of him.

I was once commissioned to paint an Alouette helicopter by the army. When it was unveiled at a black tie dinner it emerged that I had painted a Sioux by mistake. This portion of the painting, right in the middle, had to be cut out and a new piece of canvas stitched in. I then painted the correct helicopter, merging the background and presenting it again at another black tie dinner. (I got two dinners for that one!) Fortunately the joins were in the landscape where I could put the paint on thickly. If they had been in the sky it would have been far harder to disguise the join.

Here I started the main subject too high up on the canvas so I needed to take two inches (5 cm) off the bottom. I use masking tape to judge how much needs chopping off, being sure to scrape the wet paint off before applying the tape. Once the canvas has been trimmed it can be tacked back onto the stretcher.

HOW I PAINT

In any painting the challenge facing the artist is rendering a three-dimensional view on a two-dimensional surface. For me, paintings that lack the all-important elements of perspective and tonal balance appear flat and lifeless. When I've finished a painting, I want the viewer to experience a sense of actually being there.

PERSPECTIVE

In every painting I do, I use three forms of perspective to create the illusion of a three-dimensional image on a flat canvas – line, colour and texture.

Most artists are familiar with the concept of perspective lines, which meet at a vanishing point on the horizon. Just as shapes become smaller and less distinct as they recede into the distance, so do colours. As a general rule, foreground colour is bright and hot. Background colour is paler and cooler.

The naked eye sees texture clearly when things are close up. Our brain may tell us that the surface of a haystack is coarse and uneven but that's not how you should paint it if it is in the distance. A useful trick is to half close your eyes, which will cut out a lot of superfluous detail. If you were to put this detail into your painting it would have the unwanted effect of bringing the distance forward.

One of the beauties of oil paint is its versatility. For faraway objects you can apply the paint in thin veils of cool colour to create an impression of distance. In the foreground you can plaster it on so thickly you can actually feel the texture when it's dry.

BALANCE OF TONE

When I paint I don't mix all the colours on the palette itself. I get roughly the colour I want, then adjust it by adding more colour straight onto the canvas. For example, if an elephant looks too cold, I'll add some red – not necessarily all over, but in appropriate places to give an impression of warmth.

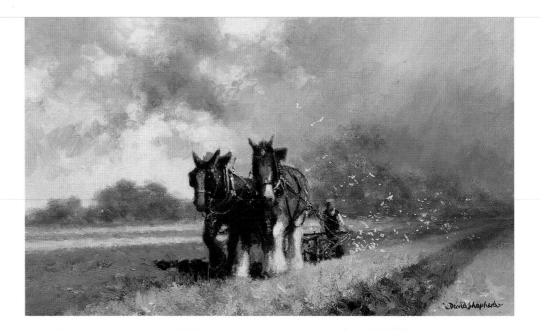

The success of a painting will depend on getting the balance of tone right. Firstly, decide which is the highest highlight, or the whitest white, then the darkest dark. Every other tone must fit in between the two. The darkest darks and the highest highlights will be in the foreground. Everything else fades into the distance and this is how I manage to achieve a three-dimensional effect.

I can't stress balance of tone strongly enough. While I'm painting I'm constantly judging one tone against another and making adjustments until I'm satisfied that I've created a painting with perfectly balanced colours and harmonies.

The Carthorse
Oil on canvas
36 × 56 cm (14 × 22 in)

The brightest whites in this painting are reserved for the horse's nose and legs and the flock of seagulls following the plough. Together they make an interesting formation that creates the focal point of the painting.

Painting with David Shepherd

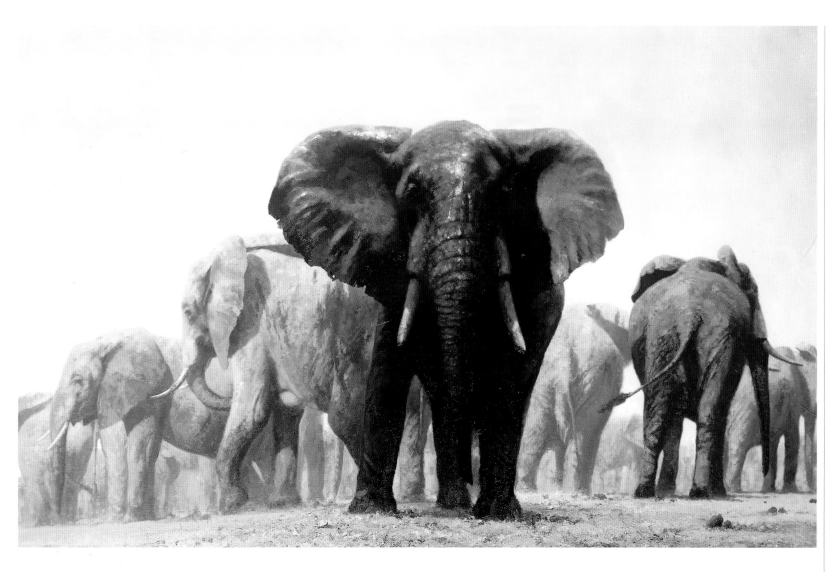

The Mudbath
Oil on canvas
81 × 86 cm (32 × 34 in)

Strong hot colour in the foreground
brings the main elephant forward.
Cooler, paler tones for the elephants
behind help create the illusion of a
third-dimension.

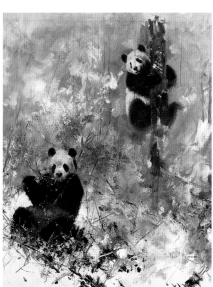

Pandas
Oil on canvas
57 × 48 cm (22½ × 19 in)

A preliminary monochromatic sketch is a
useful way to sort out the tonal values
across a painting.

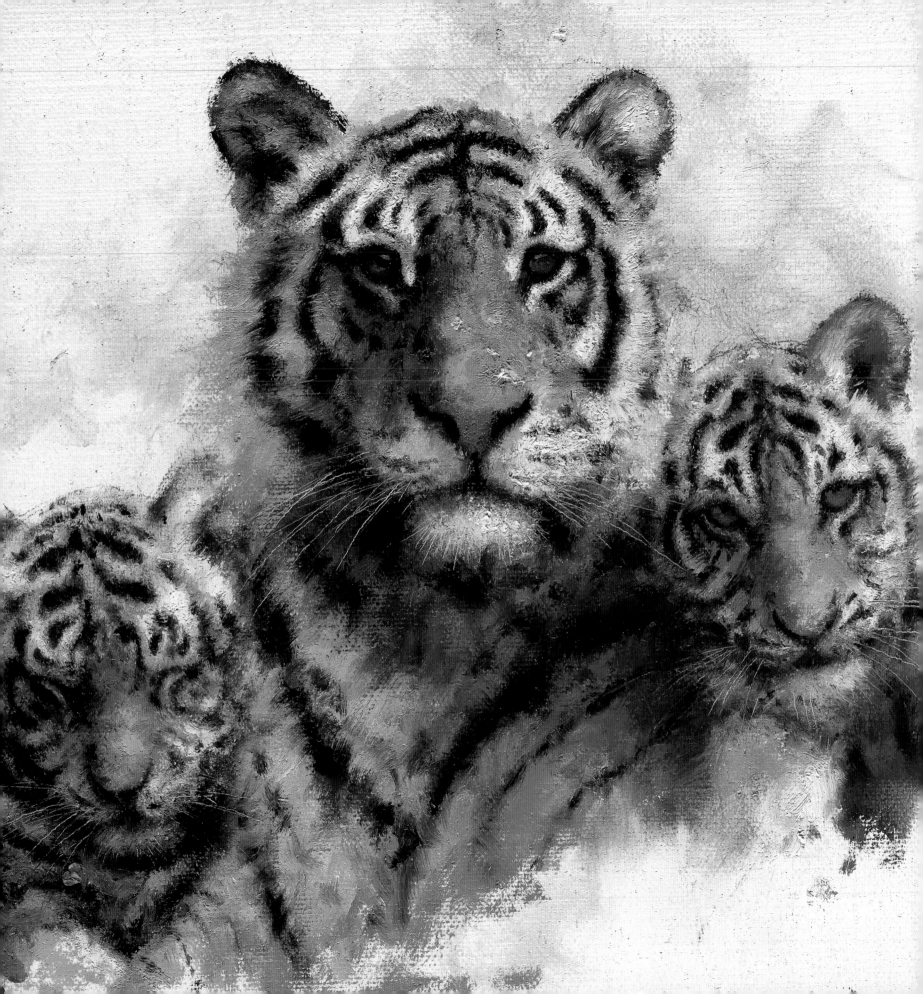

SKETCHBOOK

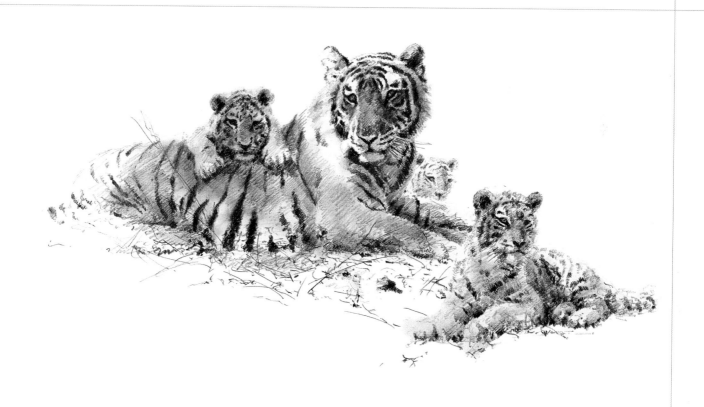

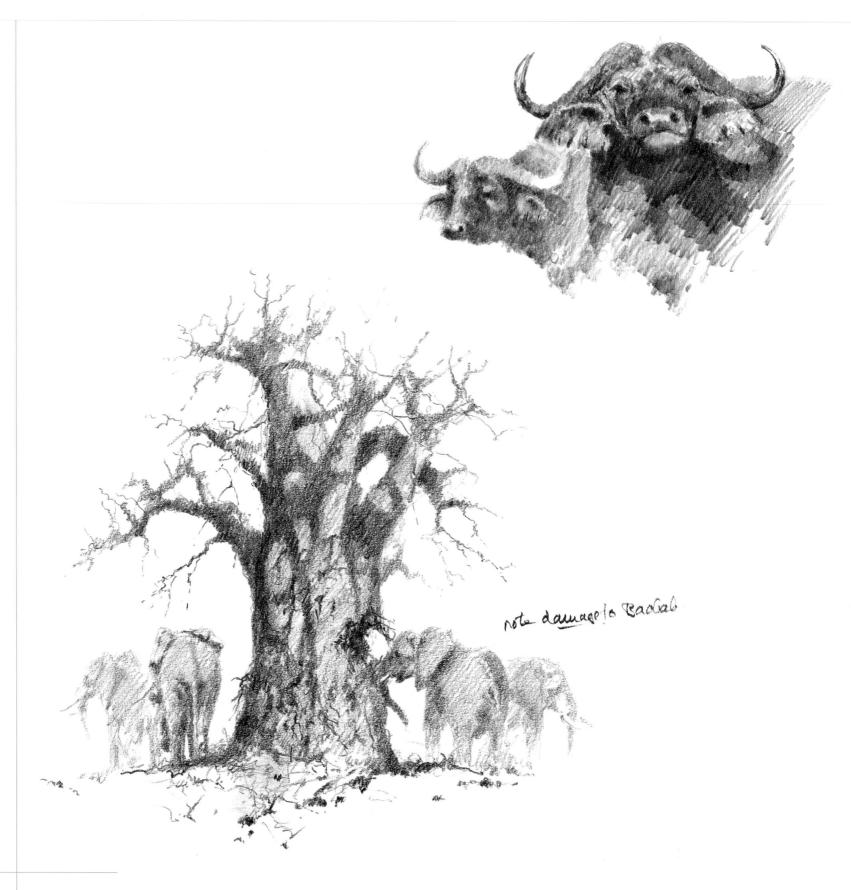

note damage to Baobab

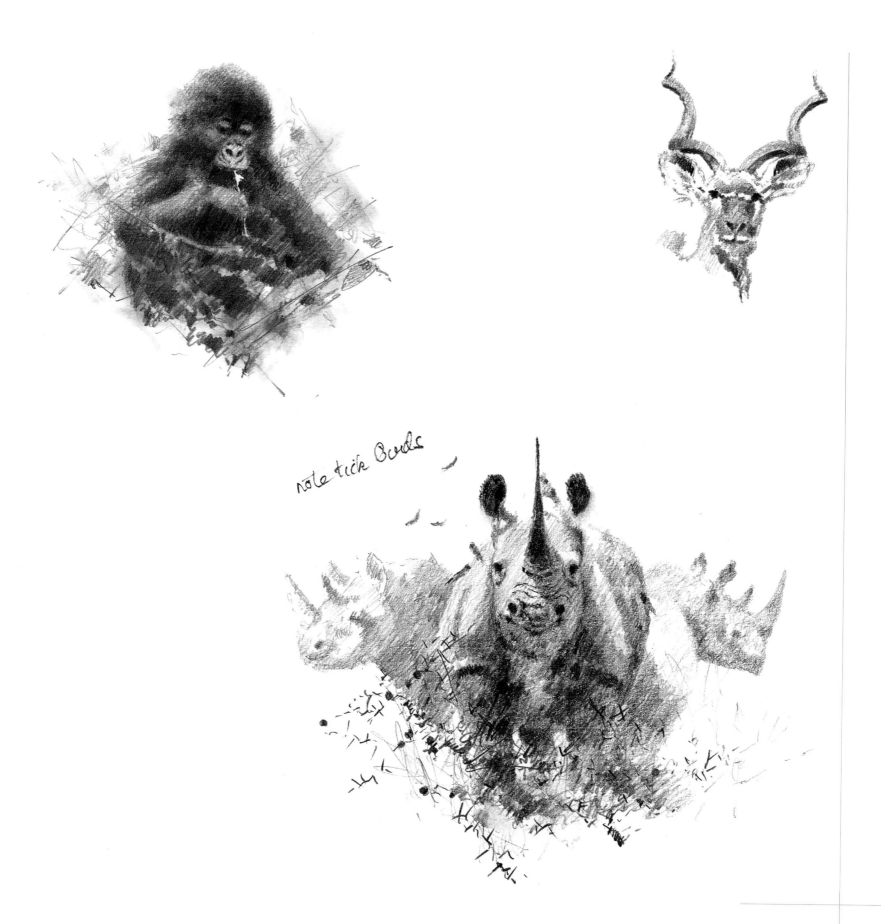

note tick Birds

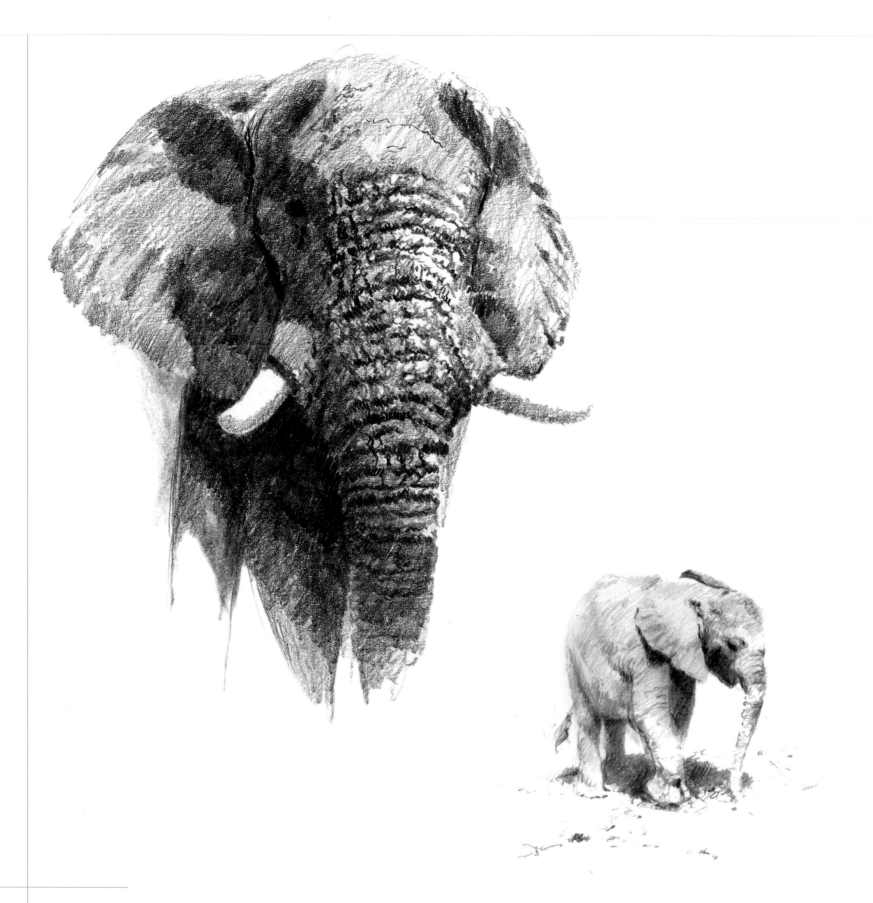

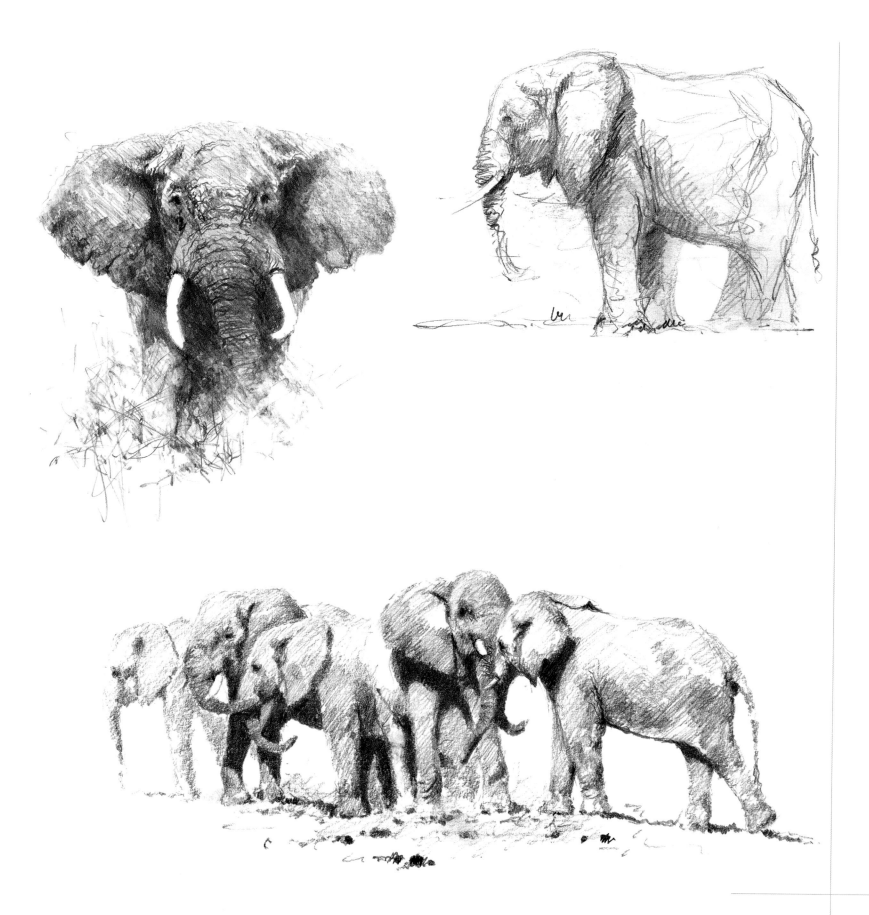

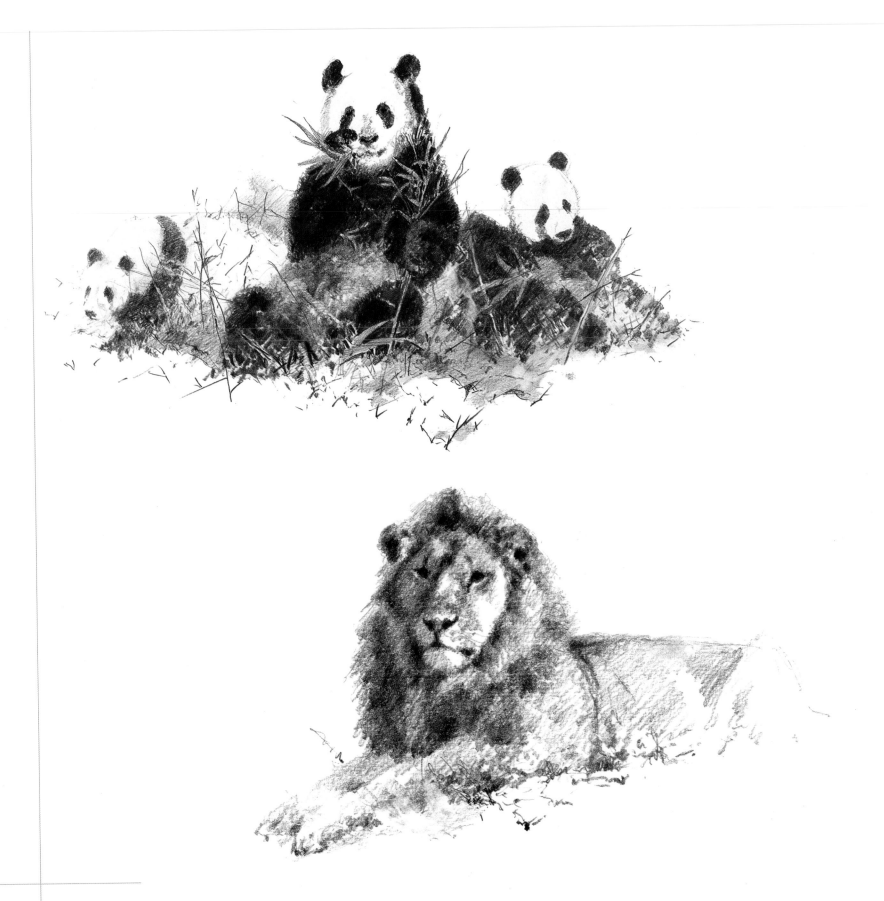

Painting with David Shepherd

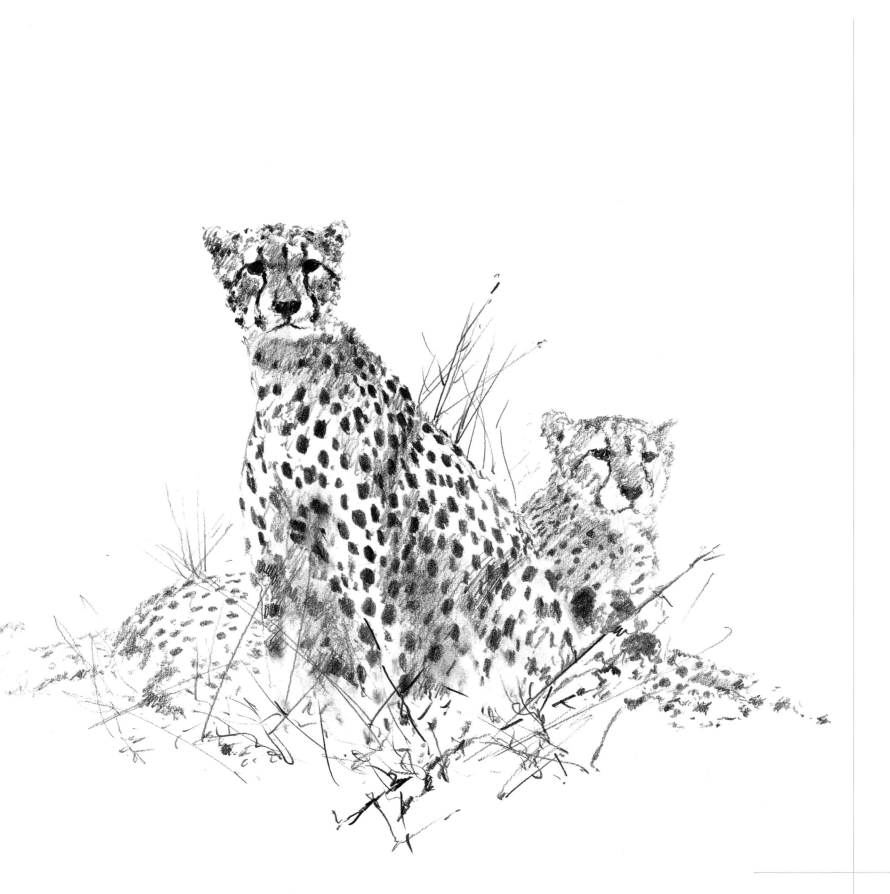

highest light is oil to side of wheel

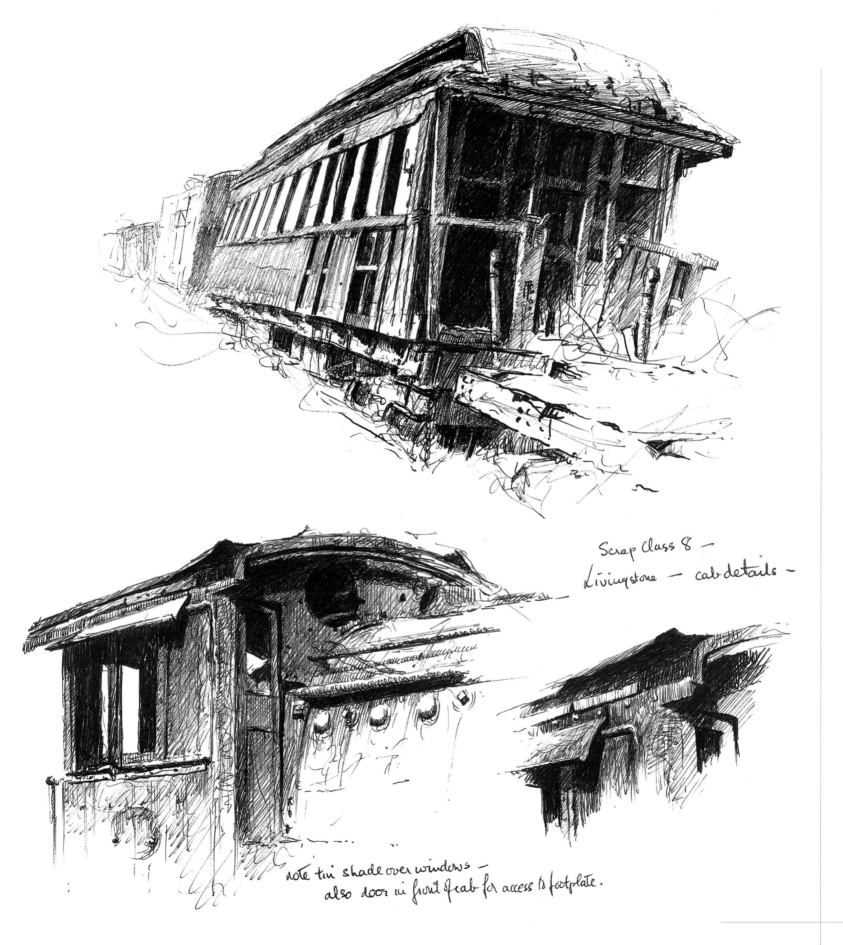

Scrap Class 8 —
Livingstone — cab details —

note tin shade over windows —
also door in front of cab for access to footplate.

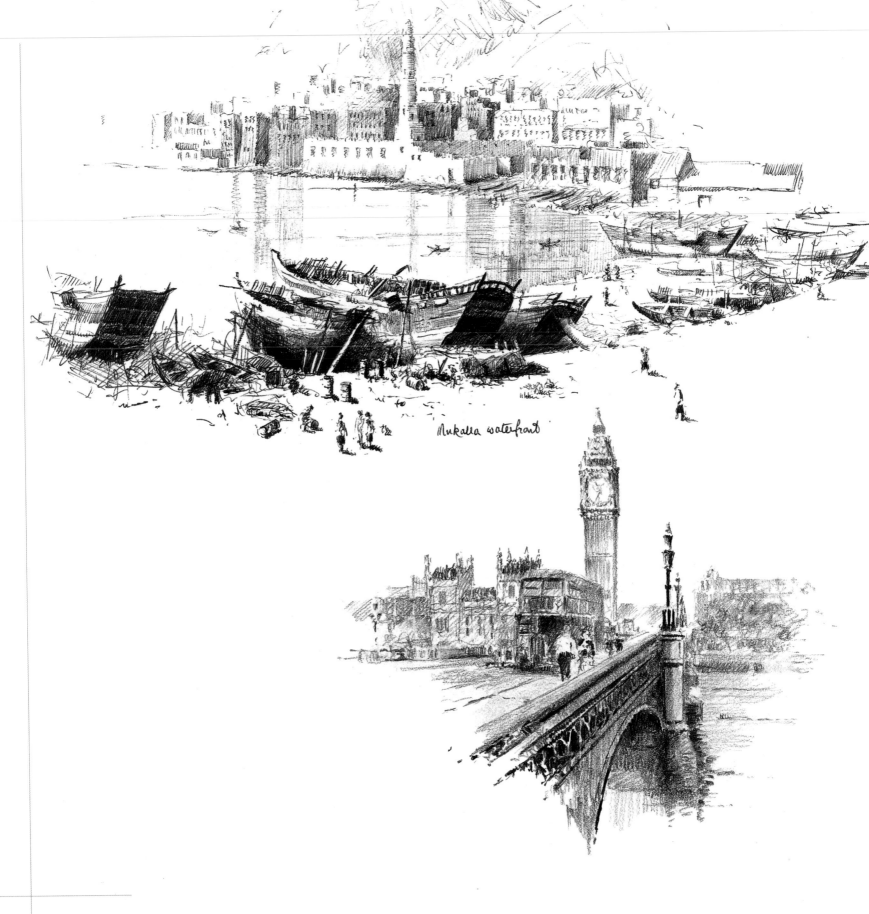

Mukalla waterfront

great textures in rubble of ancient
Ranthambhore ruins

PAINTING WILDLIFE

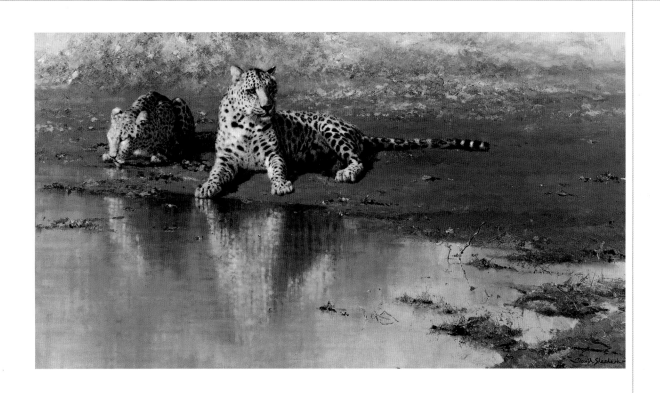

CALL OF THE WILD

Ever since I was a child I've had an affinity with animals. Although I didn't know it at the time, I realize now that it is something deep within my soul. After all these years, the excitement of being out in Africa among the animals never diminishes. Every time I see an elephant, it feels like the first time – and I realize how utterly insignificant Man actually is.

One of the essential elements in a good wildlife painting is atmosphere, and you can't get that from visiting a zoo or a safari park. Lions in zoos are fat and indolent, with unnaturally impeccable manes. In the wild, they're leaner and fitter, their faces are scarred, and their manes are usually damaged and often matted with mud. If you can't observe animals in their natural habitat, the next best thing is to watch wildlife programmes on television. At least you're seeing wildlife as it really is, albeit through a screen.

The most technically accurate animals won't make a good painting if the composition is off balance. My paintings tend to grow on the easel through a constant series of judgements, which involves positioning and repositioning the

David says...

My painting AFRICAN CHILDREN has, I suppose, a certain celebrity status (although I hate that phrase). It fetched a record price for my work at an auction at Christie's. I was flattered but a little irritated when someone rang me and said, 'David, you are doing well!' I had to point out that I did not get the money – that went to the previous owner of the painting!

animals in relation to each other and their surroundings.

In the end, for me, a wildlife painting succeeds when it conveys a sense of 'being there'. It's the yardstick that governs my choice of reference material and endures all the way through to critical assessment of the finished picture.

previous spread
Cool Waters
Oil on canvas
51 × 89 cm (20 × 35 in)

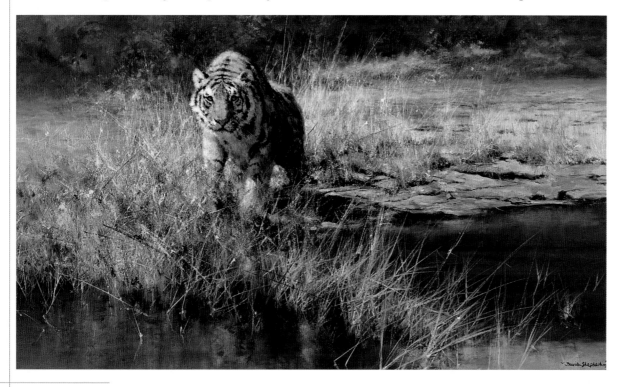

The Bhandipur Tiger
Oil on canvas
56 × 96.5 cm (22 × 38 in)

There can be no finer sight to stir your soul than watching a tiger coming down to drink from the river. Here, his shoulders rippled with sheer power, while the glorious orange and red of his coat seemed to reflect the very rays of the sun.

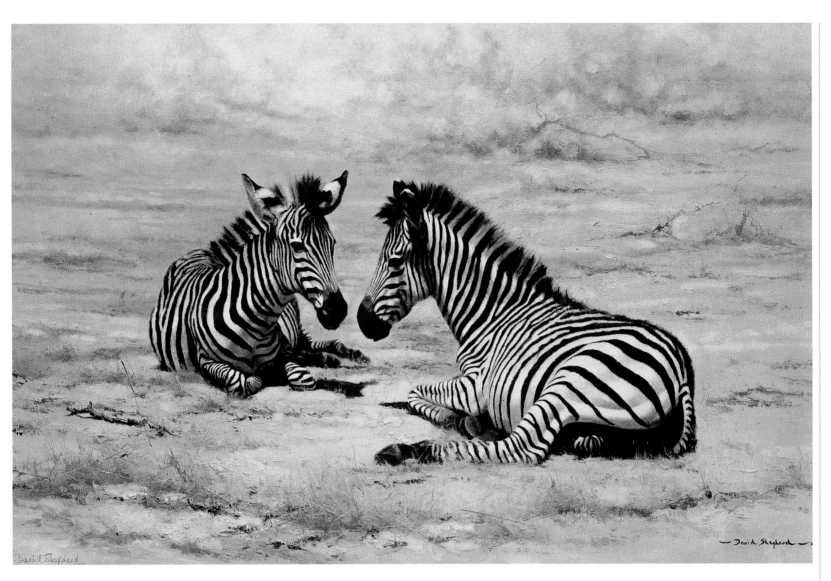

African Children
Oil on canvas
71 × 112 cm (28 × 44 in)

There is an unmistakable bond between these two young zebras.
I think the strength of the relationship between them, both in
emotional and compositional terms, creates a visual tension that
would have been undermined by the inclusion of any more
background detail.

STRIKING A POSE

There is nothing wrong with using a camera and I believe that most wildlife artists do, as you can't expect an elephant to stand still for five days while you paint its portrait. I pour film through the camera but nobody ever sees my photographs. I take pictures of bits of animals, shadows on riverbanks and anything else that attracts me. But the camera only records the shape of something. It's the atmosphere that I have to get into my head and that is what matters.

Gathering useful reference material is a question of patience and luck. I have been known to take over a dozen photographs of a piece of wood on the side of the road. As a result I had 15 different images. I call this sketching with a camera because I find it so much more convenient. If I had sketched it laboriously in pencil, half-an-hour's work would have produced only the one image.

As a professional artist working on commissions for private clients or on paintings for limited editions, the pose I select is usually governed by commercial constraints. There is little public demand for aggressive poses – the most popular ones are always non-threatening.

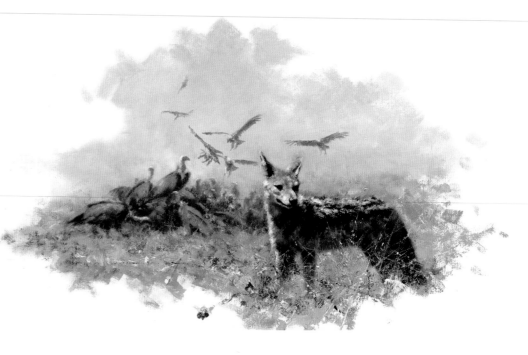

Having said that, I am careful not to descend into sentimentality when I am painting. I have too much affection and respect for animals to trade on the 'ah' factor so I would never, for example, think of painting kittens in baskets. Even in repose, an animal in the wild is part of nature in the raw – and there is nothing twee about that.

Jackal
Oil on canvas
28 × 48 cm (11 × 18 in)

Jackals, together with vultures, are known as 'Nature's dustmen'. They may not be commercially popular to paint but I love them and they are crucial to Africa's ecology. The vultures in this study give it a sense of movement, but once I'd quickly painted in the point of interest, I didn't feel it merited finishing. As a cameo it has an extra sense of immediacy.

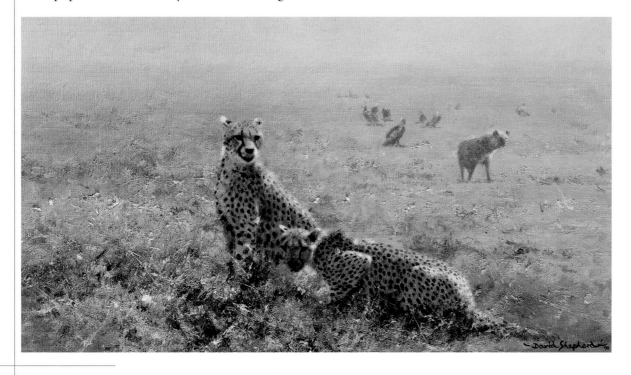

Cheetahs with Kill
Oil on canvas
33 × 61 cm (13 × 24 in)

Where a kill is included, it has to be painted with a certain delicacy. Here, the prey is secondary to the narrative drive generated by the wariness of the crouching cheetah and its mate. Something has caught their attention, but what is it?

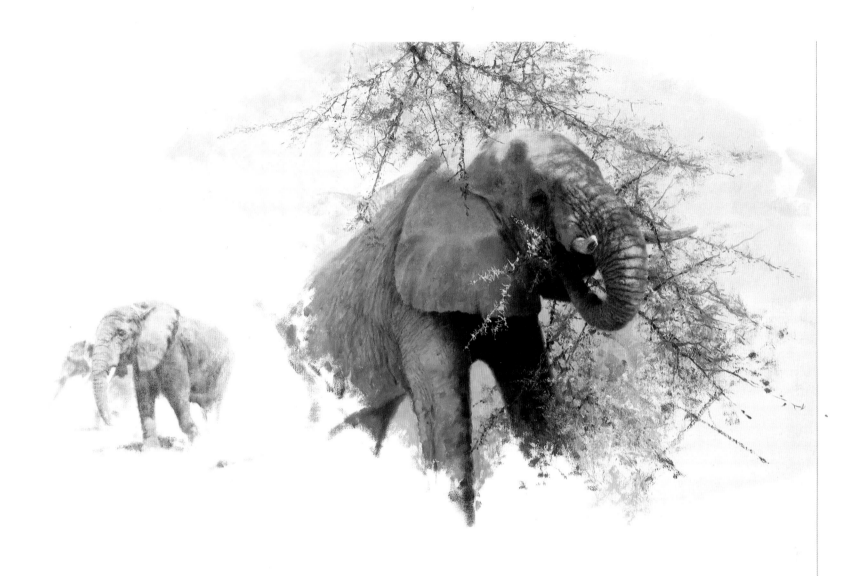

In the Shadows

Oil on canvas

42 × 72 cm (16½ × 28 in)

I was terribly excited when I came across this elephant grazing in the wild, with sunlight dappling across its trunk, and immediately realized that this would be a marvellous subject for my canvas. I managed to record the highlights and shadows with my camera but I was actually there to get a sense of the atmosphere and that's what matters. As an artist, I decided to adapt what I was seeing and I was able to design the shape of the thorn branches to frame the elephant's head.

ELEPHANTS

I was never trained in anatomy, nor have I spent time dissecting animals as some serious wildlife artists do. However, I have undertaken detailed visual observation of various species on visits to Africa and India and have found that, with practice, one can become familiar with the shapes and structures of different animals in the process.

Elephants are the largest land animals on earth and their skeletons support an enormous weight. There are significant differences between African and Asian elephants, the main being that the African elephant's spine is concave and the Asian's convex. There are, however, even significant differences between African elephants according to where they live. Zambian elephants, for example, are smaller than Kenyan elephants. They have less developed tusks and are thinner in the legs and body.

To me, it always seems that elephants have rubber limbs. They can turn without moving their legs and manoeuvre themselves into the most amazing positions. I can watch them forever; eating food in vast quantities which goes in at one end and comes out the other with equal rapidity and, if undisturbed, making noises like a motorbike rally. However, if disturbed, they can disappear into the vegetation like ghosts, without making a sound.

Years ago, the BBC Natural History Unit decided to film my life story. They suggested we went out to Zambia where I might 'paint elephants from life', which I thought sounded risky but decided to do anyway. The two experts with us assured me that if we were absolutely quiet and the wind was in our favour we could get within sketching distance, as it is the elephant's acute sense of smell, not its poor eyesight, that is its main defence. The idea of me and the 13 other members of the television crew walking up to two unsuspecting elephants with a full-size easel, 15 tubes of oil paint, a palette and brushes seemed completely bizarre but we actually got away with it. However, I do not recommend this to aspiring wildlife artists!

A CLOSER LOOK

African elephants have wonderful ears. They say that no two are alike, which is great news for a painter. They use their ears to regulate body temperature so the surface is a network of protruding veins. On a windy day, an elephant will stand downwind and spread its ears to cool itself down. They also spread their ears if they think they're under threat, which makes their heads look tremendously powerful.

An elephant's trunk is a tremendously flexible organ, used to explore the world around it, pick up food and water and wrap around other elephants in play fighting. There are deep crevasses and lots of lumps and bumps down its length, which give plenty of exciting opportunities for textural painting. At the first whiff of danger they'll also raise their trunks to sniff out the source of the threat.

Male and female elephants both have tusks, but the male elephant's tusks are thicker and heavier. They use them for all sorts of things such as stripping bark from trees, digging for salt and as weapons. They tend to be left- or right-tusked (just as humans are left- or right-handed) which means that one or the other becomes more worn over the years and may even break off.

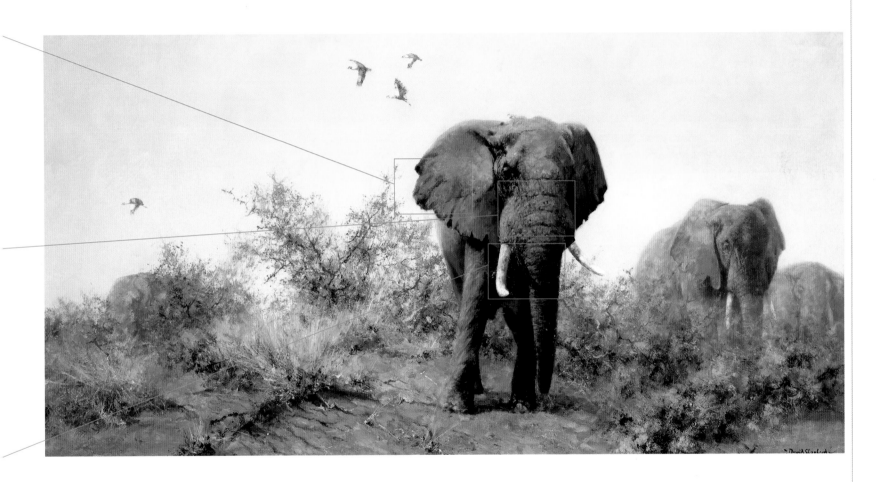

Crested Crane
Oil on canvas
51 × 102 cm (20 × 40 in)

LIONS

The lion has been known as the 'King of the Jungle' since Victorian times but I can't stand the phrase and, if an animal has to have the title, it must surely go to the elephant. Lions are, in fact, actually found in the savannah grasslands of Eastern Africa, and in dry, often desert-like areas south of the Sahara. The Asiatic lion is found only in the Gir Forest region of northwest India, and only in very small numbers.

As a guide to proportions, an adult will be up to four feet (1.2 m) high to the shoulder and nine feet (2.7 m) long from nose to tail. A mature lion's tail, including the tufted tip, will be about three feet (1 m) long, approximately one-third of the total length. The front paws are larger, for seizing prey and fighting. Mature lions have an unmarked coat, but they're born with a spotted coat of short coarse hair. The male has a mane.

Lions are the sociable cats of the animal kingdom as they are the only ones to live in groups. The pride is made up of lionesses, cubs and pride males. Once a male lion matures, he must find and fight for a new pride. As the females are the hunters, he's likely to go hungry if he doesn't succeed.

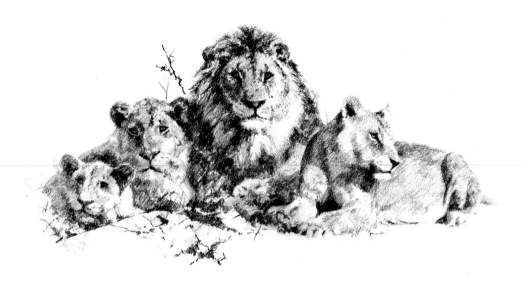

Lion sketch

I am not an ecologist, so there are many who know much more than I do about wildlife. These depictions could be criticized with justification, as it is extremely unusual to see a male lion with a female and cubs. However, I feel they work well in terms of composition.

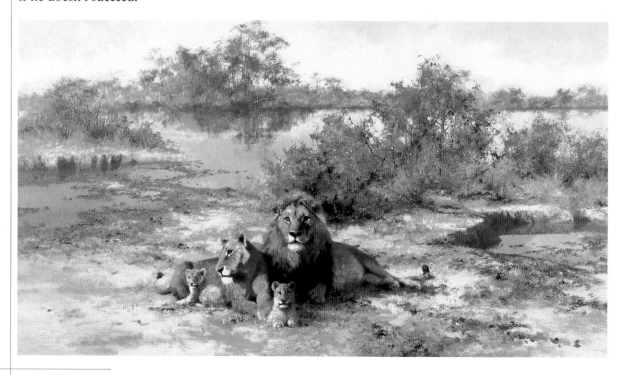

In the Cool of the Evening
Oil on canvas
43 × 76 cm (17 × 30 in)

Painting with David Shepherd

TIGERS

Tigers are generally solitary creatures, preferring to hunt alone, so they are not often found in groups apart from that of a mother and cubs. They're found in forested areas of Asia, notably in parts of India, Indochina, Russia and China.

As you might expect, tigers living in colder northern climes tend to have thicker, more shaggy coats than their tropical counterparts. Siberian tigers have a splendid ruff of hair on the sides of the head, but it's never as big as a lion's mane.

An adult male grows to about nine feet (2.7 m) long from nose to tail, but in exceptional cases they can be even longer – up to 12 feet (3.7 m). The tail is approximately three feet (1 m) long, so the proportions are similar to those of a lion.

The adult tiger's coat is reddish or pale orange, with irregular stripes in black or brown all over the body – except for the ears, throat, belly and tip of the tail, where the hair is off-white. Tigers' stripes are as individual as fingerprints, with no two tigers' markings being the same. This helps wardens on tiger reserves to identify them, and also allows for artistic licence when painting.

Big cats have the largest eyes of any meateaters. Reflective layers behind the retina project light back through the pupils which gives them exceptional night vision.

The canine teeth of both lions and tigers, used when they go in for the kill, are a massive three to four inches (7.6 to 10 cm) long.

Working sketch for a tiger painting
Oil on canvas
48 × 81 cm (19 × 32 in)

PAINTING FACIAL EXPRESSIONS

Capturing the character of an animal isn't simply a matter of technical accuracy. The real essence of the creature is caught by the glint in its eye, the surprise or alarm of a startled moment, or its docile 'butter wouldn't melt in my mouth' expression as it relaxes in the shade.

When painting species with softer, furry faces, the expression on their face is the key to conveying their mood. A tiger baring its teeth, for example, is instantly menacing. Showing those four-inch (10 cm) canine teeth leaves you in no doubt that it means business. In repose, with its mouth closed and whiskers down, it looks more friendly and appealing.

In many of the best wildlife paintings, the narrative drive comes from the demeanour or facial expression of the animal chosen as the main focus of interest. If that's the case, I find it works best to paint it big and bold, letting it dominate the canvas.

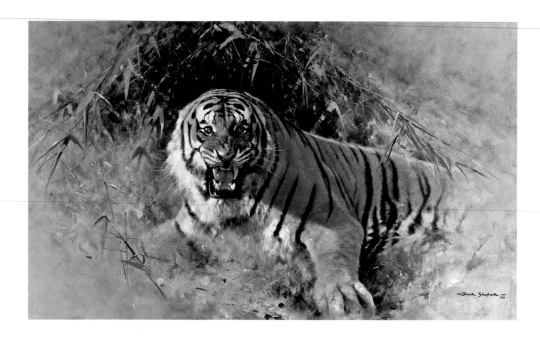

Tiger Fire
Oil on canvas
56 × 96.5 cm (22 × 38 in)

Cheetahs

Oil on canvas
30.5 × 51 cm (12 × 20 in)

Cheetahs are my favourite cats, with their regal air. I also know a number of people who have tame cheetahs and they are ideal sitters. I must have taken over a dozen photographs of one such animal. She just sat there while I moved her head and tail – she didn't seem to mind a bit!

Cheetahs love to sit up on mounds or any other handy vantage point for good distance views. You can see from the alert expression on the faces of these two that they're on the look out for prey.

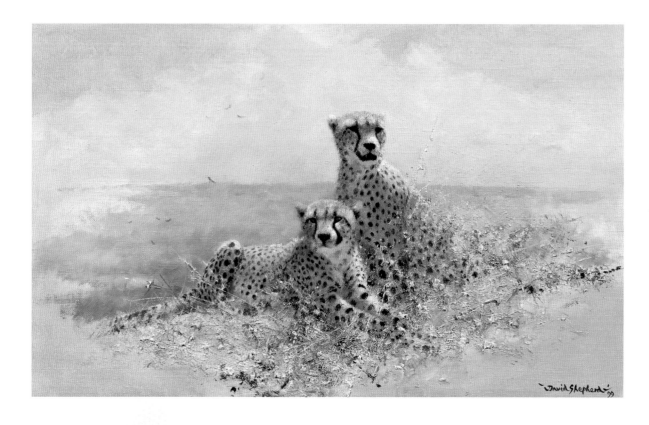

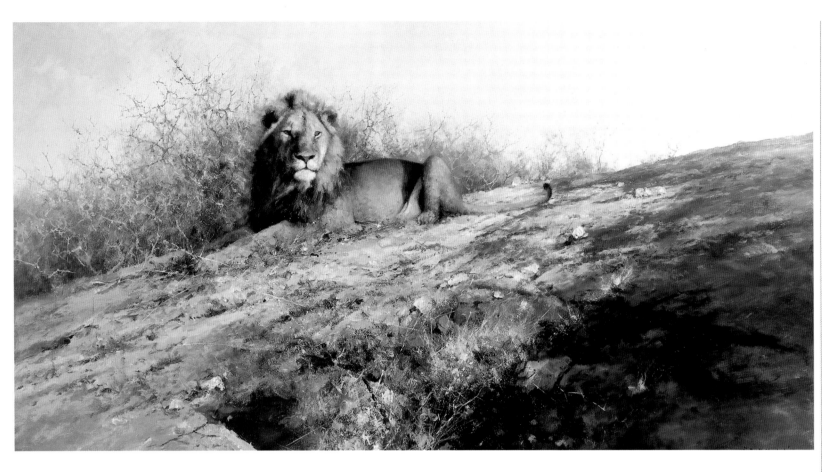

King of the Serengeti
Oil on canvas
71 × 132 cm (28 × 52 in)

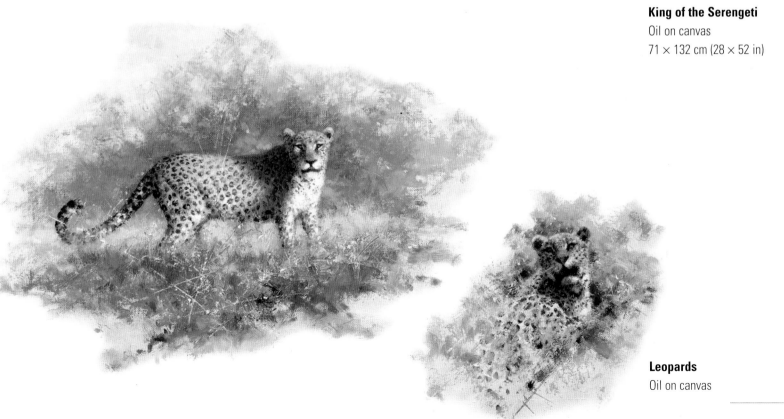

Leopards
Oil on canvas

EXPRESSION AND POSTURE

Animals such as hippos, rhinos and elephants, with their thick-skinned, leathery faces, can't convey their demeanour through their facial expression. You need to use posture in order to portray a sense of their mood. It's clear, for example, that an African bull elephant isn't pleased if you paint him drawn up to his full massive height, with those enormous ears spread out.

It is never easy to imagine what is going on in the mind of an elephant or buffalo, say, when they appear to be threatening the viewer. I prefer to see it in opposite terms: that they feel threatened when they see their greatest enemy, Man.

You can also change the character of an animal in a painting by altering the colour, as I have done below. For major adjustments you have to let the paint dry completely before adding more.

Rhino sketch
Oil on canvas
25 × 35.5 cm (10 × 14 in)

Rhinos aren't so much thick-skinned as armour-plated. They seem to look permanently sad. Many people find these prehistoric-looking creatures ugly, but I love them.

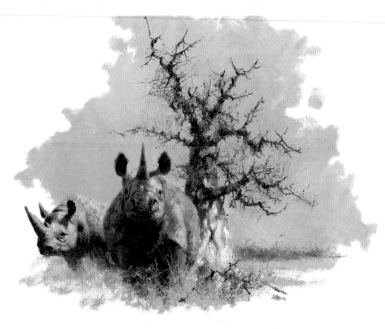

Head of the Herd

The tones of the leading buffalo must be the darkest in order to create a three-dimensional effect. I built up the colour in his head with a touch of blue on his nose and added a little Light Red and Yellow Ochre into the ears. When the paint is dry, I will use a dry brush to mist a touch of a light tone of grey over the other two buffalo, to make them recede.

Before

After

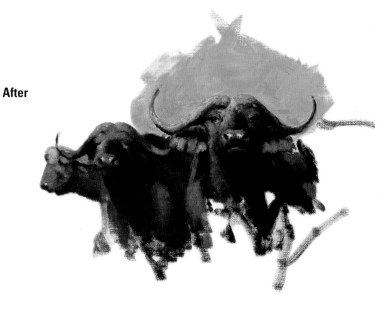

Hippo and Nile Cabbage

Oil on canvas
25 × 25 cm (10 × 10 in)

While I was driving past a lagoon in the Okavango swamplands of Botswana, this huge hippo suddenly surfaced with cabbage weed dripping from its head. It looked very comical and made me think of a fat lady showing off a rather unflattering new hat. If I'd tried to include more landscape in the scene, the humour would have been lost so I concentrated on only the one animal.

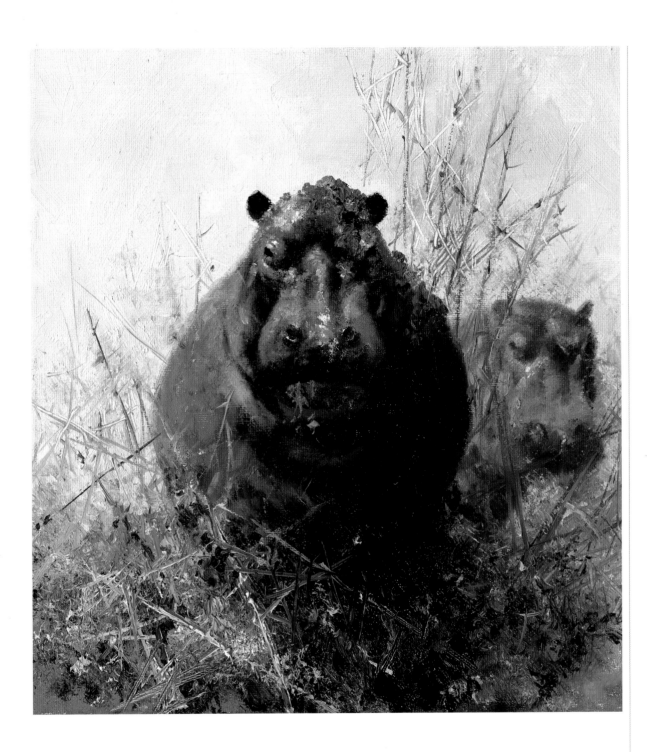

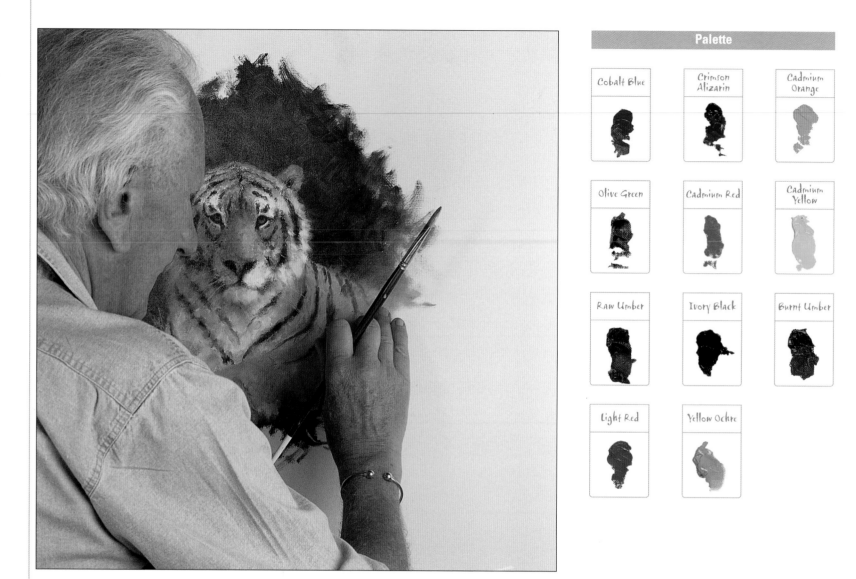

Palette

Cobalt Blue	Crimson Alizarin	Cadmium Orange
Olive Green	Cadmium Red	Cadmium Yellow
Raw Umber	Ivory Black	Burnt Umber
Light Red	Yellow Ochre	

These days I seem to spend half my life painting tigers. No two are the same, but there is a basic pattern in their markings, which match roughly on each side of the face. Eventually this will be a finished painting of a tiger in repose, but in this demonstration I'm concentrating on the head, with the body and background sketched in quite briefly.

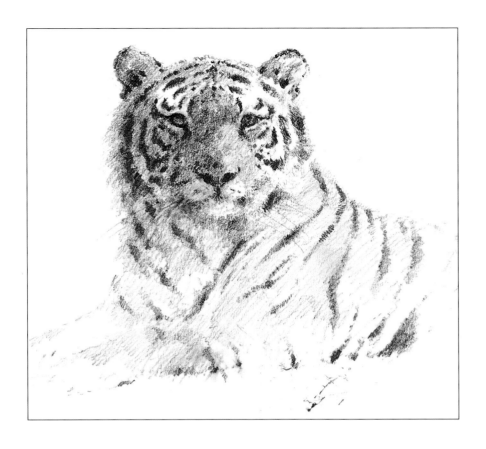

For this exercise, I decided it would be more helpful to work from a detailed pencil study.

Drawing in black and white helps the artist to assess how the tonal values work together to create a sense of structure and form. It pays to get this right at the drawing stage so you have an accurate reference.

STEP ONE Working from my study, and using a small filbert hog brush which I used throughout the painting, I started with just a few dots of Raw Umber to indicate the tips of the ears, nose and mouth. This helped to establish the proportions of the head on the canvas. With diluted Raw Umber, I then drew in a faint outline of the ears, nose and mouth, and an indication of the head shape.

I don't know why, but I always start with the animal's right eye (the left as we look at it), and work outwards to build the face. Using Ivory Black and Burnt Umber for a warm black, I painted the eye and the basic shapes around it. The character of the animal is established from the outset with the eyes. The slightest brushstroke can make the difference between a friendly and an unfriendly tiger.

The sun is coming in from the right, which will cast a shadow down the bridge of the nose and across the left-hand side of the face.

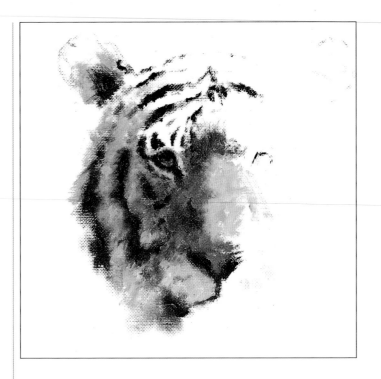

It's always tempting to paint tigers in bright glowing red, but that is too harsh and it cheapens the image. At this stage I established the shaded side of the face so kept the colour cool with Raw Umber, a fairly neutral colour. Mixing this with Light Red, Yellow Ochre and Titanium White gave it body and helped me to get rid of the white canvas, allowing me to judge the tones as the painting progressed. I also introduced soft grey shadows, using a mix of Cobalt Blue, Crimson Alizarin, Yellow Ochre and Titanium White.

I drew in the nose, using Ivory Black both for the nostrils and to indicate the line of the mouth. I brightened the rich brown with Yellow Ochre and a touch of Cadmium Orange to create the sunlit length of the nose, and blended the edge into the shaded side.

Mixing Ivory Black with Burnt Umber created the eye colour, as well as a useful colour for the dark stripes. The direction of the black and rich brown stripes helped to model the shape of the face, but I left areas of white canvas above and below the eye and across the muzzle where the fur is white.

STEP THREE Working in short strokes, I added thin layers of tonally compatible colours from the mixes on the palette to create subtle variations on the canvas. The colour on the top of the tiger's head and down the sunlit side of the face is much higher in tone. To create a strong contrast with the shaded area, I used Yellow Ochre with a touch of Cadmium Orange as a base for the brighter areas.

The mouth is an important determinant of demeanour – and this one was looking very grumpy. A slight upward curve at the corners helped to make it look less threatening, but I was careful not to overdo it to prevent it from acquiring an unnatural grin.

I switched to a bigger flatter brush to draw in the throat, using broad sweeping strokes of thin warm black in a skimming dry-brush technique, as well as to widen the head shape. This was only roughly established at this stage.

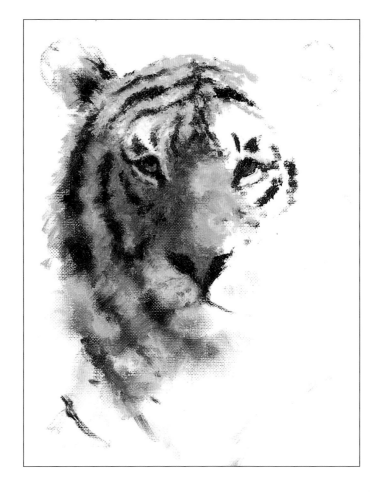

When I'm painting a furry animal such as a tiger, I use my fingers as much as the brush to blot and soften the colour. I can't emphasize enough the need to do so in order to keep edges furry and indistinct.

STEP FOUR It's important to balance the background colour against the overall colour of the tiger. This tiger is quite low-key, so a bright green would come forward and swallow it. As it is the main subject it must stay optically in the foreground of the painting. I used a sludgy green, made from Burnt Umber and Olive Green with touches of Ivory Black and Titanium White, applied in broad random strokes.

The final shape of the tiger's head was created by painting the background colour up to the edges of the head, over-painting where necessary into the edge of the head until I achieved the right shape.

I cooled the whites on the shaded side of the face with Titanium White, tinged with some Cobalt Blue and an even smaller amount of Crimson Alizarin. Beware – it is a powerful colour! To create an outline I was satisfied with, I pulled the wet face paint out onto the background with my fingers, creating a fuzzy outline. This, of course, is only possible when all the paint is wet.

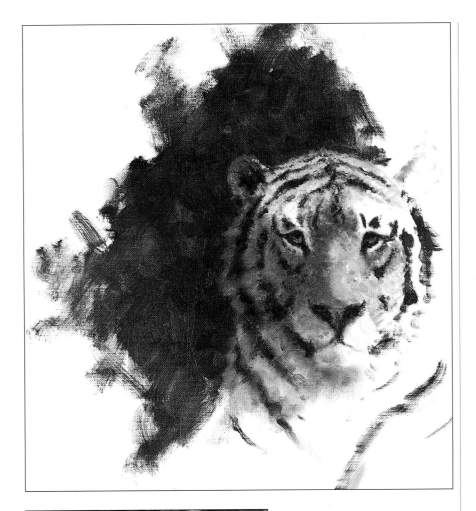

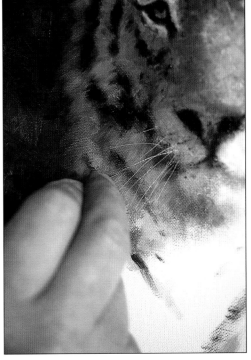

Soft grey shadow smudged under the chin moulded its shape, and working it up at the corners of the muzzle gave the tiger a friendlier demeanour. I added irregular dots of warm black on the muzzle for the hair follicles and scratched in the whiskers with a pin.

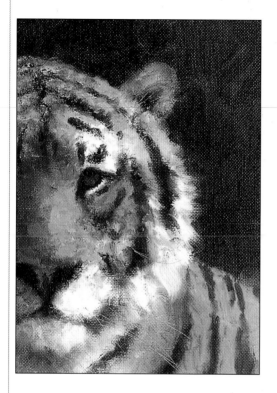

I continued around the head shape with the background green, shaping it to match the other side. Darkening the background green around the white edge of the face sharpened the contrast further, and made the tiger jump out from the canvas.

Using the Yellow Ochre and Cadmium Orange mix, I mapped in the sunlit back, and added a few marks to indicate the black stripes and shape of the forelegs.

At this stage, I stood back from the painting to judge the overall tonal balance, and decided that it needed deeper tones on the shaded side of the face to balance with the darkness of the background, and touches of Cadmium Red and Cadmium Yellow to warm the sunlit fur. Touches of Cadmium Yellow and Titanium White created the brightest highlights in the sunlit areas of the rich brown fur.

Black stripes with hard edges were softened using one of my bashed-up brushes. I picked up a little of the dark paint on the splayed bristles and drew it out lightly to make individual hairs.

I added pure Titanium White on the chin, above the eyes and around the jowls on the sunlit side, smudging it into the background for a fuzzy effect. In all my paintings, pure white is reserved for the very brightest white areas. Used too liberally, it loses its power as a highlighter.

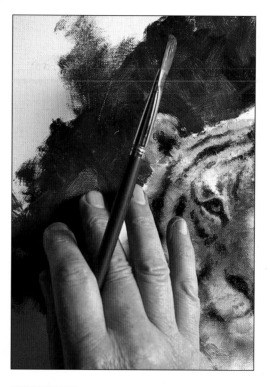

To break the solidity of the background colour, I wiped away small areas with my finger to give the impression of patchy sunlight struggling through the greenery.

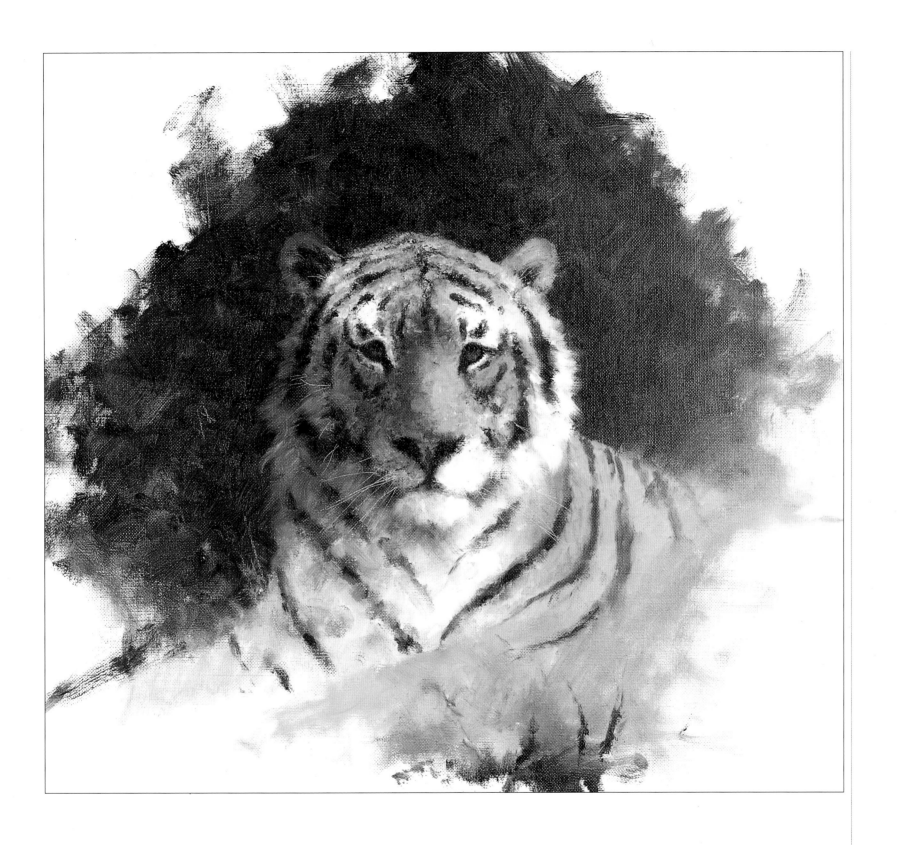

YOUNG ANIMAL FACES

The faces of young animals are less defined than those of mature adults. The bone structure and muscles are still developing so their faces appear softer and flatter, and their bodies more supple.

Baby elephants are covered in coarse hair that looks like a thinning crew cut! They're born with milk teeth and little tusks only two or three inches long, which drop out at about a year old. The permanent tusks begin to extend beyond the lips of an elephant at around two to three years of age, and will continue to grow throughout its life.

Elephant Calf
Oil on canvas
15 × 15 cm (6 × 6 in)

Lion and Cub
Oil on canvas
13 × 23 cm (5 × 9 in)

This study of a young male lion with a cub demonstrates the differences between the faces of a baby and an adult. In reality, they'd rarely be seen together like this.

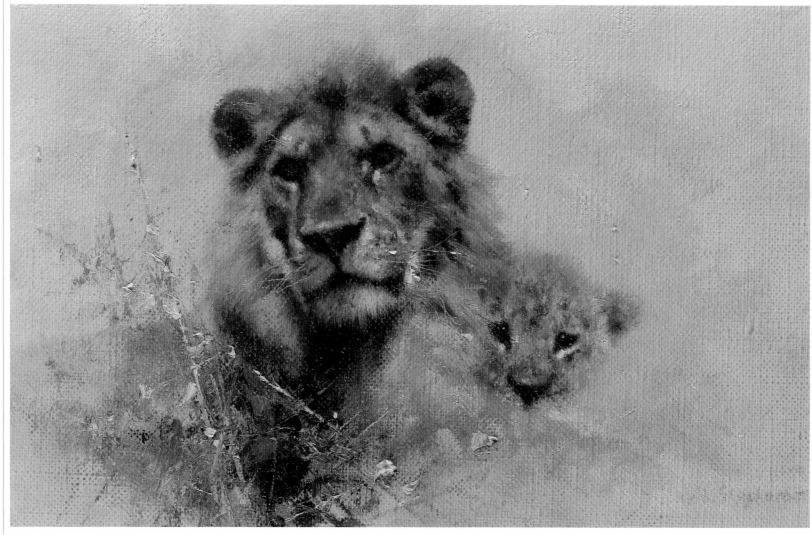

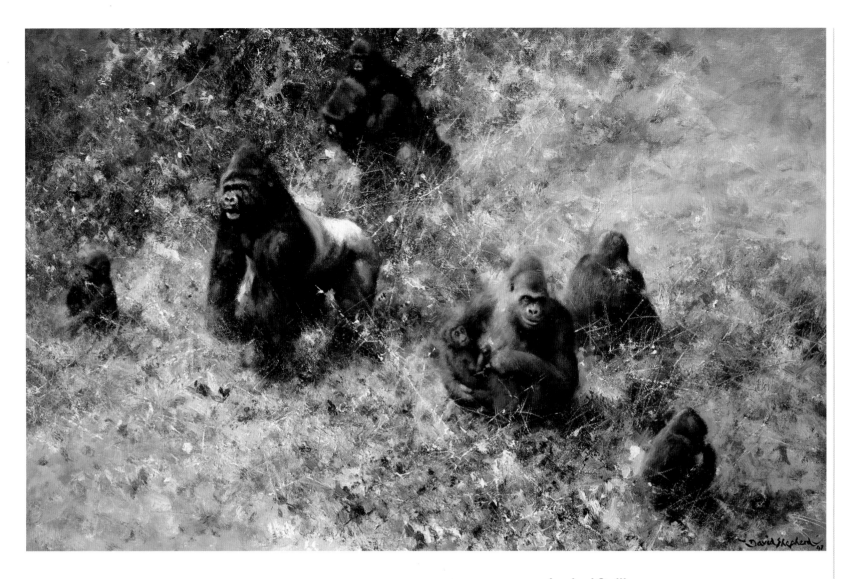

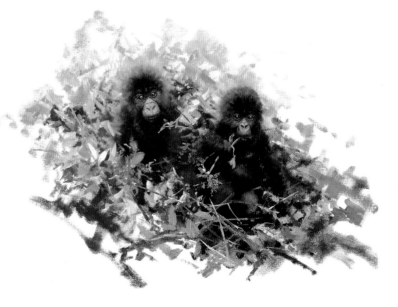

Lowland Gorillas
Oil on canvas
46 × 71 cm (18 × 28 in)

A devoted gorilla mother and baby is an irresistible painting subject. Females keep their babies clamped to them for the first three months. The young cling to their mothers for transport and don't walk on their own until they're about a year old. A baby gorilla has a round appealing face, with huge glassy brown eyes that seem to see in all directions at once. Its head has yet to develop the massive domed skull of the adult.

One of the biggest emotional thrills I have had in my years as a wildlife artist and conservationist was to sit with a group of lowland gorillas. The family were within just a few feet of us, taking no notice whatsoever. It gave me a marvellous opportunity to take photographs.

ETERNAL TRIANGLE

Throughout this book I have made reference to the importance of composition when it comes to the success or failure of a picture. It's one of the key elements that determines whether or not a painting works.

The most skilfully executed painting of an animal and its habitat will, at best, be mediocre if the positioning of the individual parts don't work together to create a harmonious whole. If you get the 'shape' of the overall painting right you're halfway there.

For me, the triangle is one of the strongest compositional devices available to an artist, and one that I would recommend to leisure painters who struggle with composition. I have to confess that I didn't set out to base so many of my paintings on a single triangle or a series of interlocking triangles. In fact, I didn't realize how fundamental the triangle was to my work. It's an arrangement that comes as naturally to me as the Golden Segment did to Renaissance artists and many who followed them. When it was pointed out to me, it set me thinking – not so much why I do it, but why it works.

The Golden Segment is the area that's considered to be the optimum position within a painting in which to place the main focus of interest. It's a static, prescribed area, located at the intersection of imaginary lines that divide a picture into thirds.

In compositional terms, triangles are more concerned with strengthening the impact of the focal area and moving the eye across the whole surface. They are natural directional shapes. Used to frame the main subject, or interrelated across the canvas, they literally point the way around a painting, bringing the eye back to the focal point.

Hyena
Oil on canvas
38 × 66 cm (15 × 26 in)

In this study of a pair of hyenas, the animals themselves form a strong focal triangle, which is in turn complemented by the triangular shapes of the background thorn and sky.

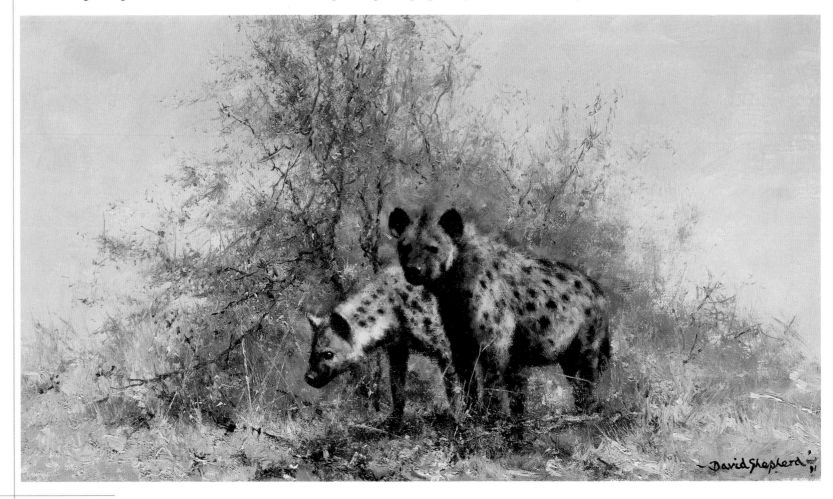

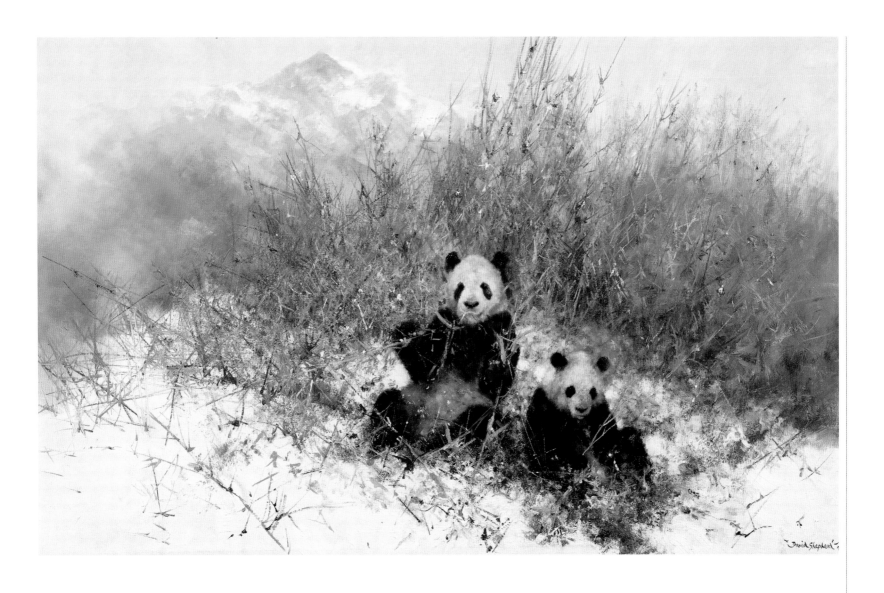

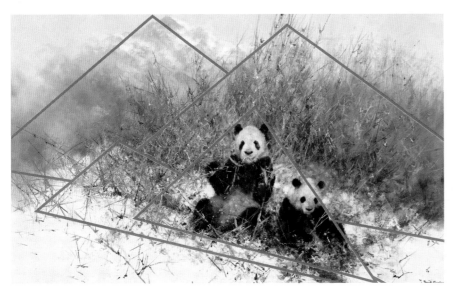

Wolong Nature Reserve, Sichuan Province
Oil on canvas
56 × 86 cm (22 × 34 in)

At first glance, this painting may not appear to be made up of a series of triangles. If that were immediately obvious it would look too contrived. But when you break it down into its main component shapes, the composition is based on a series of irregular triangles that fit together and create a balance across the surface of the painting.

BACKGROUND STORY

When I'm on my travels I'm always on the look out for interesting and unusual settings for future paintings. As I mentioned earlier, I take lots of photographs of the scene in general and of details that might come in useful – an interesting rock formation, a tree, a swamp or pool, a chunk of dead wood – whatever catches my eye. If time and conditions allow, I set up my easel and make a quick oil colour sketch on the spot.

It goes without saying that, whatever the type of wildlife I'm painting, the setting must be compatible with that particular animal's natural habitat. Having accepted that constraint, there are a number of approaches open to the artist.

Painting the animal within the context of the general landscape gives the viewer the strongest feeling of 'being there', and it's especially appropriate where the surrounding landscape has special features of interest or the animal itself has a particular impact on the landscape.

When the aim is to create a study of an animal, rather than a major painting with powerful narrative, I usually go for a close-up, completely framed by a particular feature of the subject's natural environment. Alternatively, I may decide on a cameo, with much of the background left unpainted or only briefly sketched. The paintings selected for this section show how these approaches work in practice.

Bison in Yellowstone National Park
Oil on canvas
40.5 × 66 cm (16 × 26 in)

When I first came upon these bison, they looked as if they were taking a sauna among the geysers belching clouds of steam and sulphurous fumes. There was only one way to convey such a breathtaking scene, which was to paint the bison as part of that glorious broader landscape.

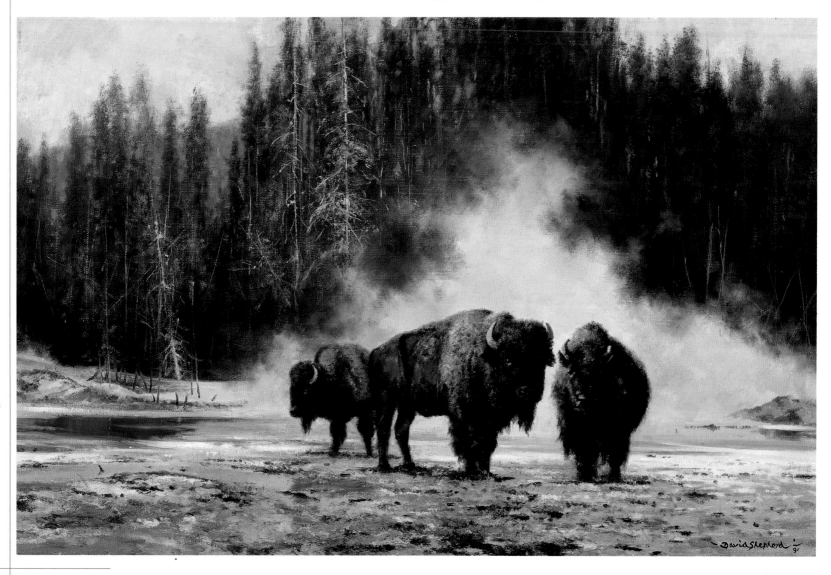

Koala

Oil on canvas
56 × 43 cm (22 × 17 in)

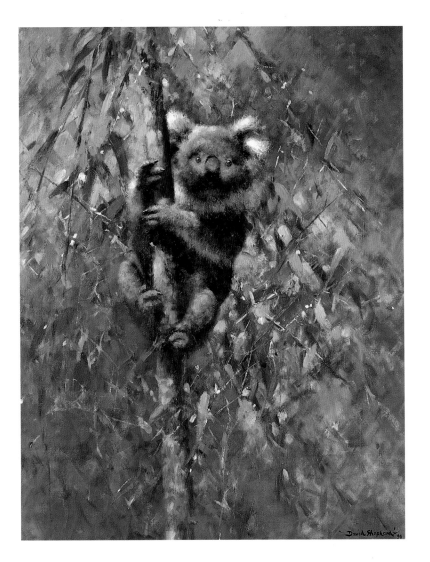

When koala bears aren't feeding on eucalyptus leaves, they're snoozing among them, so I decided to paint this one entirely framed by foliage. Some critics have said that the use of a detailed style for the bear and a more impressionistic treatment for the background doesn't work. Others have said that the blurring of the background, a technique widely used in portrait photography, helps focus attention on the subject. I'm not sure which, if either, is right, but the main thing when it comes to criticism is to listen and consider the point.

Meerkats

Oil on canvas
18 × 33 cm (7 × 13 in)

Meerkats are such comical animals that they never fail to provoke a smile. These little fellows didn't need a complex setting so I decided to place them in front of their burrow and let their innate appeal speak for itself.

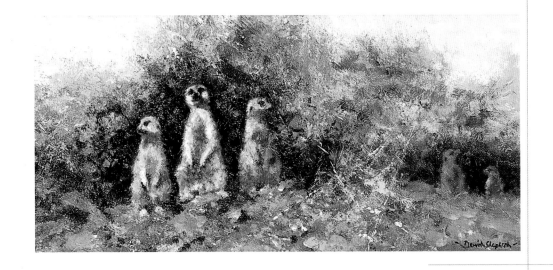

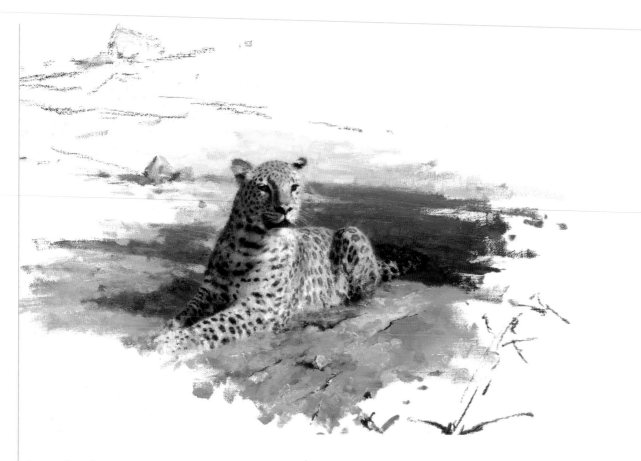

Leopard study
Oil on canvas
51 × 76 cm (20 × 30 in)

Once I had completed this study of a leopard, I felt it could be ruined if I finished the whole. The minimal charcoal line work used to sketch in the background is designed to frame the subject and retain the visual tension between the animal and its setting.

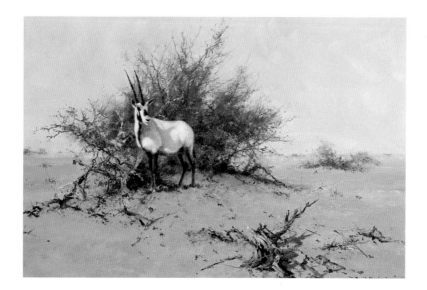

Oryx
Oil on canvas
30.5 × 45.5 cm (12 × 18 in)

The Arabian oryx lives in desolate desert areas. In the heat of the midday sun, they often seek out whatever shade they can find beneath one of the few trees that manage to grow in this inhospitable landscape.

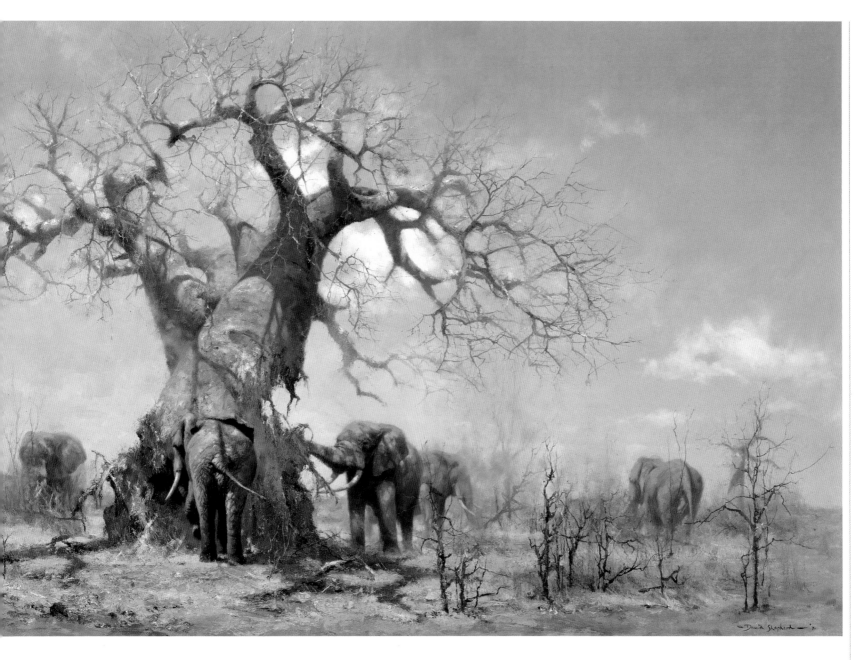

Baobabs in the Luangwa
Oil on canvas
86 × 157.5 cm (34 × 62 in)

Baobabs are wonderful subjects to paint as they
provide such interesting shapes and lovely
colours. However, it is sad to see a tree that is
centuries old being damaged by elephants. Here,
the young mopani trees never have a chance to
grow, due to over-grazing by elephants, which I
have shown in this painting.

LET THE SUN SHINE IN

Sunshine is the single common denominator in all my wildlife paintings. There are some very skilful wildlife paintings where sunlight doesn't feature, but for me, however well executed they are, they look flat and cold.

I believe light and shade are essential in the creation of form and the portrayal of a three-dimensional shape within the constraints of a two-dimensional surface. Emotionally, sunshine and shadow bring a painting alive, evoking a response in the viewer.

When I start on a new wildlife painting, the direction of the light is the first decision I make. In an African scene, an overhead sun will immediately place the scene in the daytime. Shadows are low in tone, short and sharply defined. Early morning and evening light is softer, often tinged with a golden or rosy glow. The light source is lower, so colours are more diffuse, and shadows are longer and higher in tone.

Once you have decided on your light source and time of day, you have to remain consistent throughout the painting. As the work progresses, even the most experienced artist can make a mistake by adding an ill-considered shadow that wouldn't appear in the lighting conditions.

As I paint, I'm constantly checking that areas of light and shade 'read' correctly. If an inconsistency creeps in, I wipe it away and paint that area again. When you're working in oils, you can do that. It's a much more forgiving medium in that respect.

Burning Bright
Oil on canvas
48 × 81 cm (19 × 32 in)

The essence of this painting lies in the interplay of high and low tones. There is a real sense of excitement as the tiger breaks through into a shaft of sunlight and leaps into the water. To sustain the drama, the highest tones are reserved for the tiger, the reflection and the topmost leaves catching the sun as it pierces through the dense foliage.

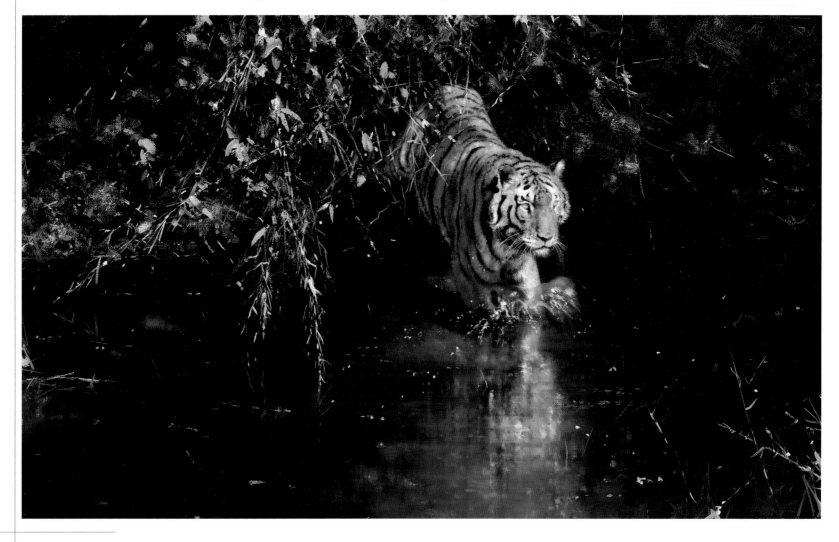

First Light at Savuti

Oil on canvas

58.5 × 101.5 cm (23 × 40 in)

It is not often that one sees a dominant male lion with females and cubs but it does occur. The drama of the scene is emphasized here by the strong use of shadows and sunlight, particularly that lighting the right-hand side of the splendid adult male.

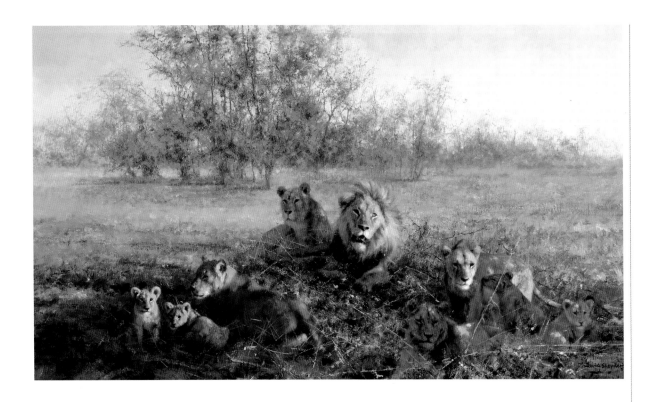

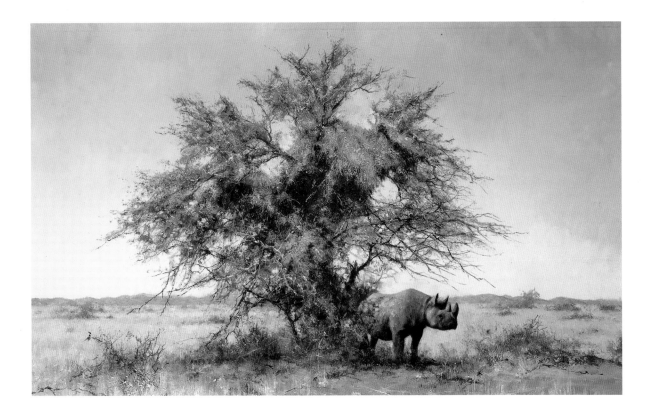

Kalahari, Rhino and Sociable Weavers

Oil on canvas

45.5 × 76 cm (18 × 30 in)

Here, I have tried to portray the vastness of the wonderful red, sandy Kalahari. Rhino, decimated to the point of near extinction all over Africa, have now been reinstated into this wonderful and vast private game reserve. The tree under which this one was sheltering in the midday sun had been colonized by thousands of weaver birds, to the point where the nests were so huge and heavy that they may well have brought down a branch or indeed the whole tree.

STEP-BY-STEP DEMONSTRATION: Elephant

Palette

Burnt Umber	Raw Umber	Cadmium Yellow
Yellow Ochre	Ivory Black	Cobalt Blue
Crimson Alizarin		

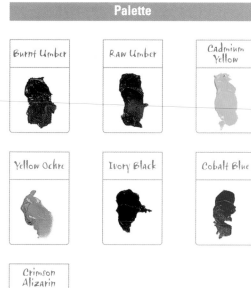

For the purposes of this demonstration, I have chosen just one elephant, but it will eventually form part of a larger painting of a group of bulls. I often launch straight in without a clear idea of how the finished painting will look. The composition tends to grow organically as I work my way across the canvas, positioning and repositioning the different elements until I achieve the right balance.

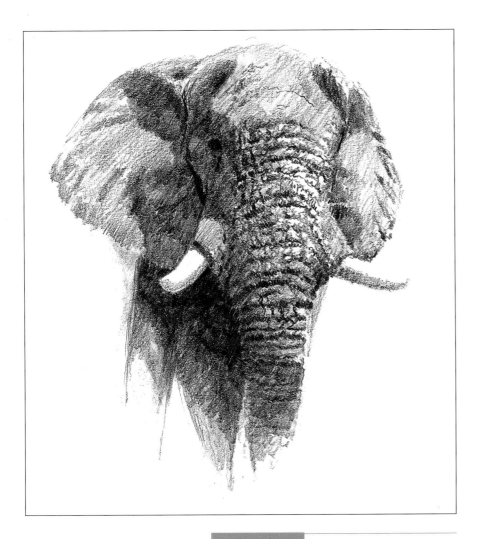

PRELIMINARY SKETCH I started by making a detailed pencil drawing of an elephant. This was full of information about form, texture and tone, providing me with an accurate reference to refer to while I painted.

Obviously, there are few opportunities out in the wild to sit in front of a bull elephant and ask him to pose for you. (I have occasionally tried it, but I wouldn't recommend it!) For this reason, it's inevitable that much of my reference material for elephant paintings is based on my own photographs. I've taken hundreds of them over the years. Sometimes I work from several prints, selecting and extracting pieces of information from each one.

STEP ONE From the pencil drawing I made a sketchy outline on the canvas, drawing straight onto the surface with a brush dipped into thin Raw Umber. I use turps substitute to thin oil paint until it is almost the consistency of watercolour. I find that this is ideal for drawing in an outline and prefer it to charcoal.

At this stage the outline drawing is just a positioning guide. Once I start painting, the elephant will take shape through the relationship of the light, mid and dark tones observed from the pencil sketch.

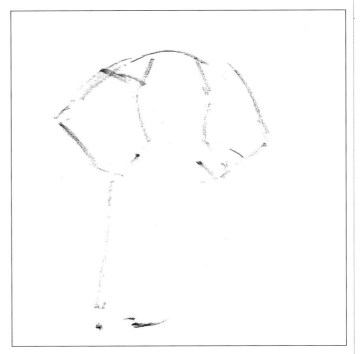

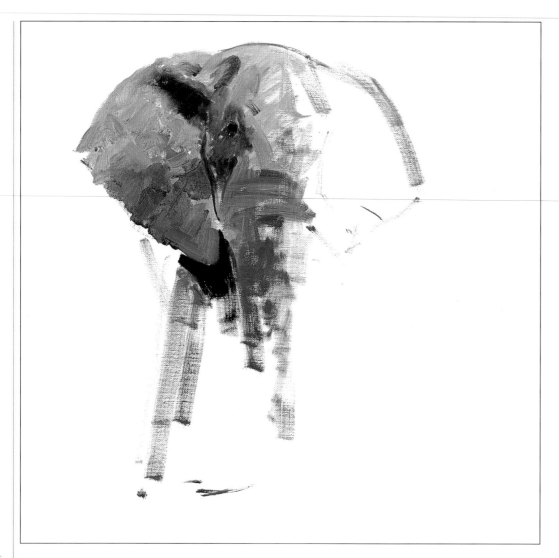

I always seem to start painting from the left (the right-hand side of the actual animal), using thinnish paint to lose the white canvas and get the basic shape in place.

It's important to decide at this point which way the sun is shining and to use the shadow to define the bone structure of the head. This is a midday sun, shining almost directly down but slightly from the right.

The basic elephant colour here was Cadmium Yellow, Yellow Ochre, Raw Umber and Titanium White, roughly mixed on the palette, to create a 'mushroomy' base colour on which to build.

Elephants come in a huge variety of colours, depending on the type of mud and dust they wallow in so it is difficult to decide which colour to use. In the Tsavo National Park, Kenya, the earth is a rich orangey red, so one can legitimately say that one has seen 'pink elephants'!

Once you have your base colour on your palette, darken it with a touch of Ivory Black for unlit areas and lighten it with Titanium White for more sunlit parts. As you work on mixing, you'll build up a range of tones on your palette.

Oil paint has a rich juiciness, which allows you to push the paint around on the surface of the canvas. In a thick form it produces wonderful textures, and it can also be blended directly on the canvas, resulting in subtle effects.

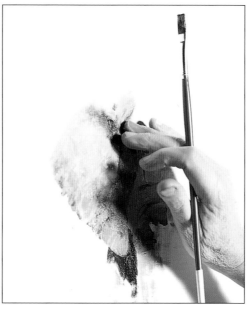

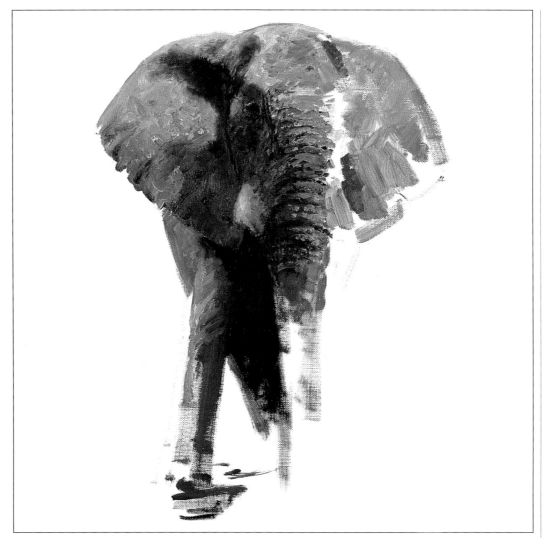

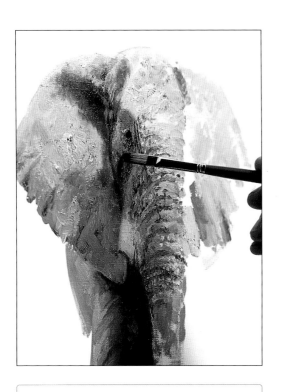

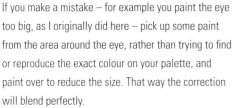

If you make a mistake – for example you paint the eye too big, as I originally did here – pick up some paint from the area around the eye, rather than trying to find or reproduce the exact colour on your palette, and paint over to reduce the size. That way the correction will blend perfectly.

STEP THREE To create the definition between the ear and the side of the face I added a warm dark shadow colour, made from Burnt Umber and Cobalt Blue, which I drew in with the brush down the left side of the trunk. It's important to soften the edges as you go. I usually use my finger to blend the shadow into the sunlit areas. More shadow was added under the eye and blended down towards the tusk area.

Next, I blocked in the trunk with a mid tone, and painted the lines across in a dark tone, using the chisel edge of the brush. Then it was time to roughly map the body, before moving on to establish the other ear. Again, I used shadow blended into lighter areas while thinking about the skull's bone structure.

The same technique was used to model and shape the side of the trunk, using light tones to throw it forward and darker tones to give the impression of depth going through to the elephant's rear.

I then established the shape of the legs, blending dark shadow down the unlit edge. By now, I had realized that the elephant's leg was too long and thin but one can always make changes when painting in oils. The body is receding into the distance so I softened the outline, in order to create this effect.

STEP FOUR By this point I'd reached the exciting part – adding more texture and detail. I used the fine chisel edge of a flat brush to paint in veins on the ears, and added irregular impasto paint across the lines of the trunk to give it a lumpy texture.

I used a small filbert to put in the eye – approximately halfway between the top of the head and where the tusk comes out.

The area of the face where the tusk emerges is sunlit, but it must not be so high in tone that it competes with the bright white of the tusk itself. I made the shape by wiping away the paint while it was still wet. The staining left behind had just enough colour to create a light tone, without fighting with the white of the tusk, which was added next.

The tops of elephants' ears bend over backwards, so I often 'lose' the edge, as I did here, by using my finger to merge the ear colour into the background or sky colour while it is still wet.

The main sky was painted quickly with random strokes of Cobalt Blue, but it was important to work more carefully around the elephant to preserve the integrity of the outline. I weakened the colour as it dropped towards the far horizon to suggest distance, and floated a trace of Crimson Alizarin into the wet paint to impart a distant red glow that suggests the intense heat on the African plains.

You don't have to paint each blade of grass to get the effect of scrubland. Here I bashed the head of a hog brush against my leg (you can also use a table-top!), splaying the bristles in all directions. I then picked up a random combination of neat earth colours such as Yellow Ochre and Burnt Umber on the tips and applied this to the surface with quick strokes, working upwards in the direction that grasses grow.

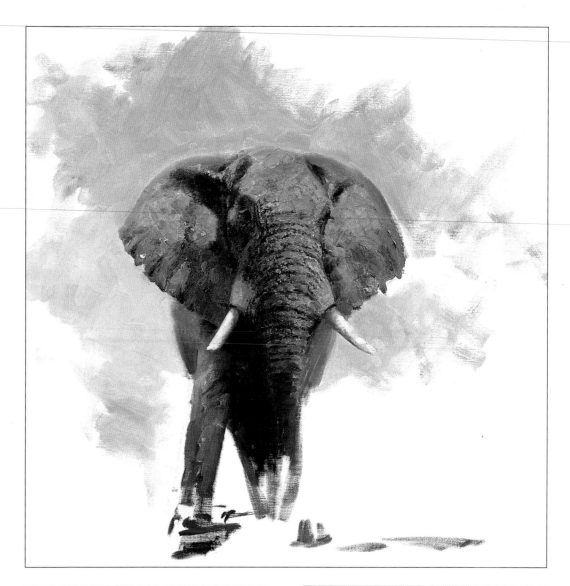

As I mentioned, this elephant has ridiculously long legs and is far too tall. Here, I increased the height of the grass covering the bottom third of the elephant's legs. The picture is developing now, as you can see on the opposite page, but the legs are still too long.

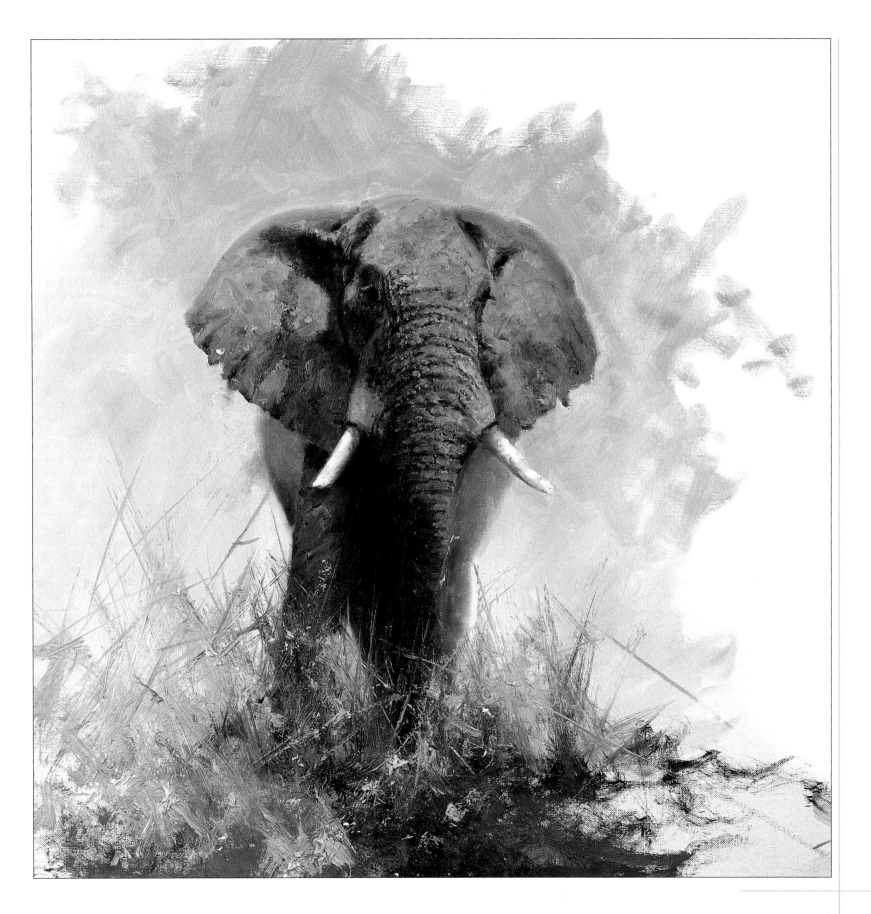

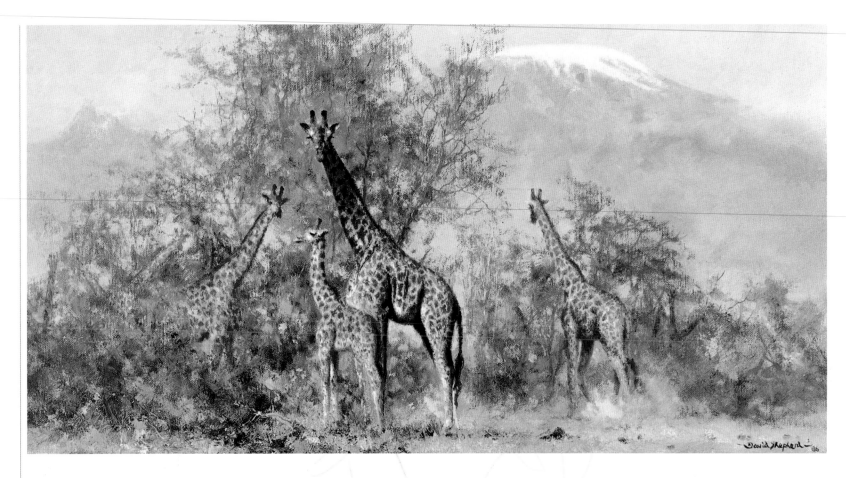

GROUP DYNAMICS

When you decide to paint a group of animals, whether of the same or mixed species, it's important to bear in mind the authenticity of the grouping.

Lions are very social animals. Females and cubs live in prides, sometimes numbering up to 20 or more individuals but only very occasionally with a couple of young males. It is more likely to see fully grown males in groups of two or three, and these are often brothers who were originally from the same pride. Group scenes of female lions work very well, but if you tried to portray a group of adult males, all with splendid full-grown manes, it would stretch artistic licence beyond the limit.

When painting a mixed group, I always bear in mind the relationship that these animals would have in the wild. Some species coexist quite happily and may even depend on each other. Egrets, for example, are often found in the company of elephants, taking advantage of the insects that the elephants disturb as they tramp through the scrub.

In any group, I always have a main character that provides the focus of attention. The others become, in effect, bit players in the scene.

If you're working from a photograph, it's unlikely the animals will have conveniently positioned themselves into a pleasing composition. It's up to the artist to move them around until they create a balanced grouping.

By balanced, I don't mean a regular grouping with the left and right sides evenly matched. The scene will be much more credible if it appears to be a random grouping that just happens to create a harmonious composition.

If I sense an imbalance, but don't want to add more animals as a counterbalance, I use elements of the setting to correct the composition. A strategically placed tree or bush can cover up part of the painting that I don't like and draw the eye back to the main focus of interest.

High and Mighty

Oil on canvas

30.5 × 61 cm (12 × 24 in)

Within this group, the star is clearly the tallest giraffe, with her wonderful long neck and curious gaze. She's the one making direct eye contact with the viewer, and the one that immediately catches our interest. However, it would have been wrong to position her in the exact centre in the picture. Instead, I grouped the giraffes to the left, and used the bright white snow-capped mountain on the right to balance the composition.

Evening at the Waterhole

Oil on canvas
48 × 81 cm (19 × 32 in)

I rarely include more than one or two species within the same picture, but I think this painting works. The placement of the different animals creates an interesting composition, while the relative dimensions of the elephants and impala accentuate the sheer scale of an adult elephant within the landscape.

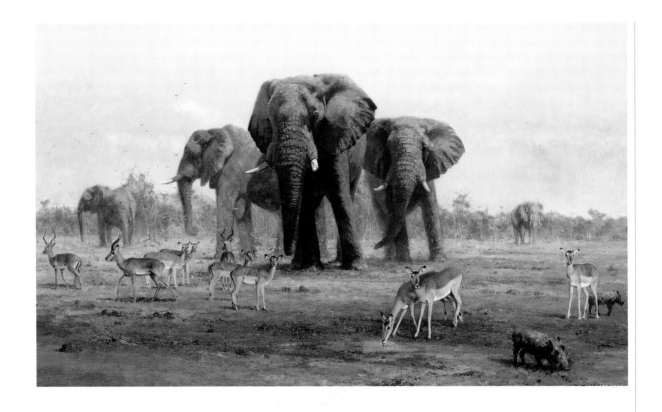

Orang-utang

Oil on canvas
51 × 96.5 cm (20 × 38 in)

This composition wouldn't have the same appeal without the mother and baby. They pull the group together and the closeness of their relationship adds narrative drive to the scene.

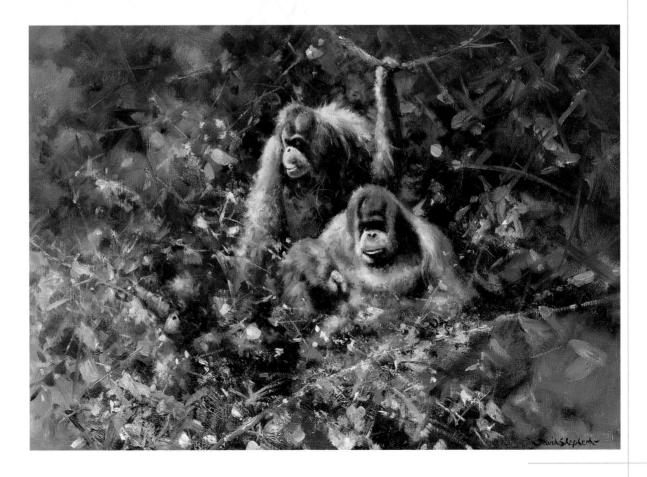

CLOSER TO HOME

In my long career as an artist and conservationist
I've been very lucky, visiting many countries
around the globe and seeing such a diversity of
animals in the wild. But much as I love to travel,
I also love to come home to England where we
have our own rich assortment of wildlife.

For the aspiring wildlife artist who isn't able to
go so far afield, there are plenty of opportunities
to paint our own native animals. The same
guidelines covered in this chapter apply equally
to wild and domestic animals in Britain.

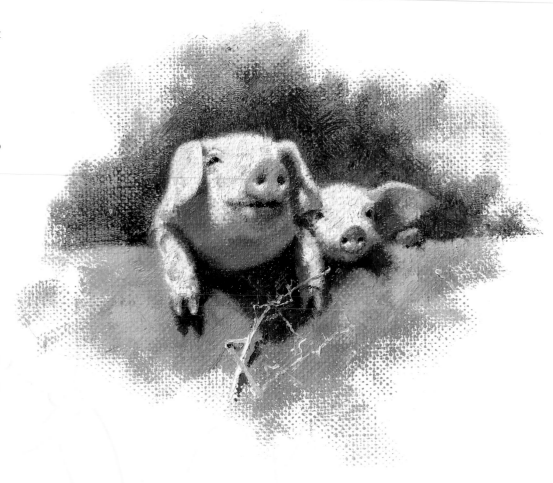

Piglets
Oil on canvas
23 × 25 cm (9 × 10 in)

I hope my lifelong love of pigs shines through in this little study of
two porkers peering over a wall on a hot summer's day. The deep
rose colour on the pigs and the rich Burnt Umber on the wall
inject life and warmth into the shaded areas. Shadows don't
have to be cold.

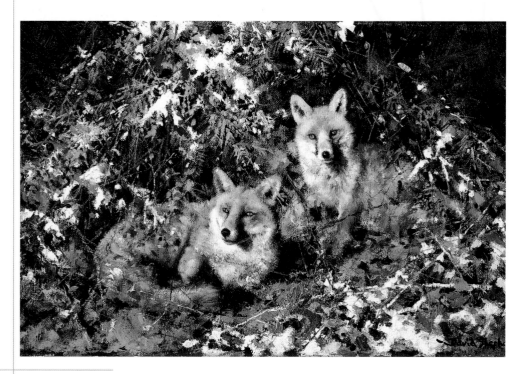

Winter Foxes
Oil on canvas
23 × 35.5 cm (9 × 14 in)

It is always ideal if one can photograph a tame animal, whether it
is a fox in England or a cheetah in Africa, bearing in mind the
difference between wild and zoo animals. Misty was a tame
animal who posed obligingly here – and in fact appears twice in
the painting! The strong diagonal brush strokes help to frame the
subjects but I was careful not to let this look contrived.

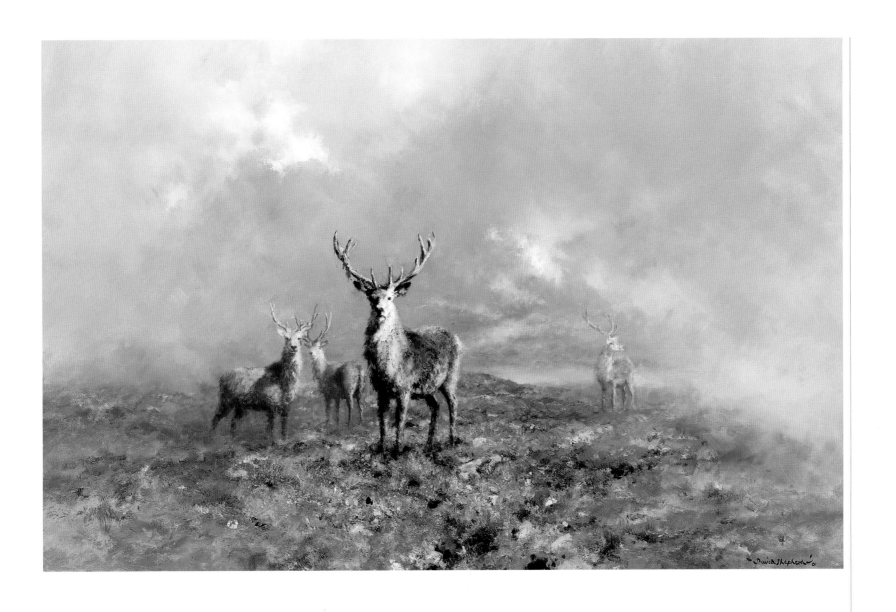

Prince of Rannoch Moor
Oil on canvas
61 × 81 cm (24 × 33 in)

I spent a lot of time in Scotland
experimenting with oil sketches of
Rannoch Moor to provide a fitting setting
for this regal stag, as you can see on
page 89 . The brooding sky and low cloud
provide a dramatic backdrop as he
materializes through the mist.

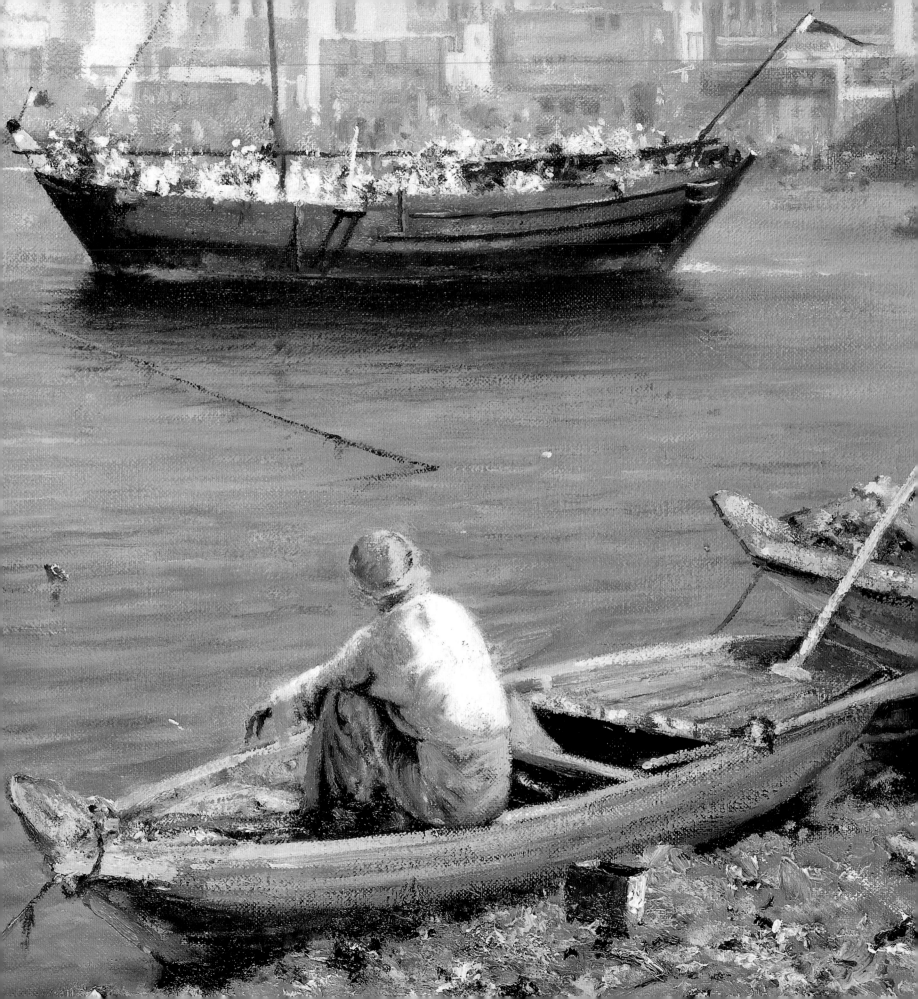

PAINTING LANDSCAPES

CREATING A SENSE OF PLACE

Whether you're painting a rural or urban landscape for its own sake, or as a setting for a specific subject, there are many factors to consider. Conveying a true sense of the place requires careful observation and attention to detail.

Without light there is no colour, but the quality of light varies in different parts of the world, and the effect that it has on colour is a fundamental consideration in landscape painting. In a way it's harder to paint a Scottish landscape than, say, a desert scene because it demands greater subtlety in colour mixing.

You don't need a selection of palettes for different subjects and settings. Over the past 50 years, I've painted all over the world using the same set of 16 colours. The skill lies in mixing, heightening and lowering tones to achieve the balance you need. To inject heat and generate atmosphere, you need lots of hot colours and warm tones. To depict colder climates, choose cooler, more muted colours.

Painting quickly on the spot is a great way to loosen up. I'm constantly trying to free up my painting style. I don't want to be as free as the French Impressionists, but it's boring to paint so tightly that the result looks like a photograph. I believe that your style develops over time, both from your own personality and from the experience that you gain over the years.

David says...

Some of Constable's sketches, painted in the heat of the moment out in the fresh air, had to be done quickly to avoid an impending thunderstorm. To my eye, they are better than his famous HAYWAIN which has everything in it and looks more laboured. I'm always aware of the danger of falling into that trap.

Shibam
Oil on canvas
51 × 76 cm (20 × 30 in)

Of all the places I've been in the world, Shibam in Wadi Hadramaut has to be in the top three. When I saw those amazing towering buildings made of mud brick, they took my breath away. Freya Stark described it as the Chicago of the East and I could see why. I knew the strong vertical lines would add drama to a painting.

I did some sketches and took photographs. I didn't have time to paint it on the spot – and you never knew when waste water and other things were going to gush out of the pipes in the walls!

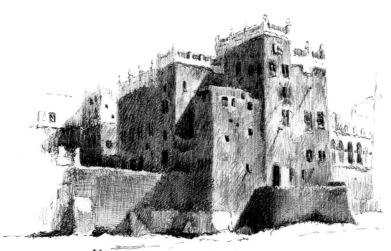

In the Hadramaut – typical mud brick architecture.

'SHIBAM'
IN THE WADI HADRAMAUT - ARABIA - 1960
David Shepherd –

previous spread
Old Dubai
Oil on canvas
51 × 89 cm (20 × 35 in)

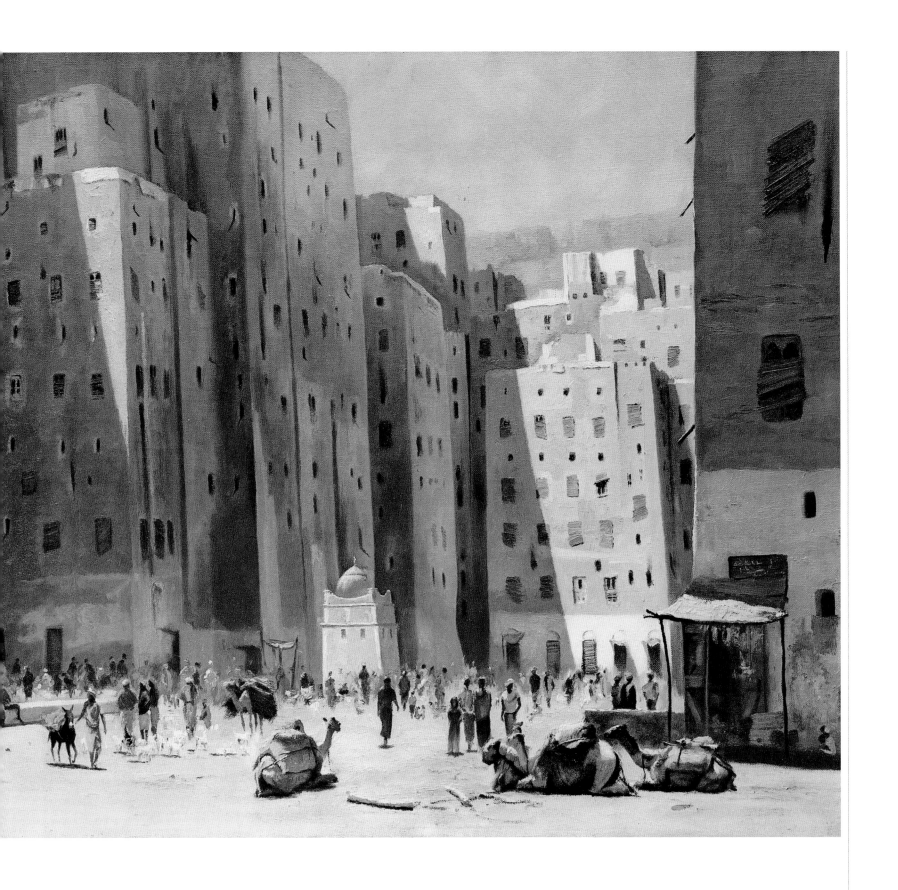

SOAKING UP THE ATMOSPHERE

Aden in the 1960s was everything I imagined it should be. It was an artist's paradise with its poky little shops and narrow alleyways, teeming with sheep and goats, who also served as the local refuse disposal service. It was filthy and smelly, but that just added to the atmosphere.

I even saw a camel push its way into a baker's shop and steal a loaf. The shopkeeper chased it out and the startled animal dropped the bread on the ground as it left. He picked it up and put it straight back on display! When I came to paint *Street Scene in Aden*, I had to include a camel. I just wish I had more time to paint subjects such as this now.

On the Way From Sharjah
Oil on canvas
41 × 56 cm (16 × 22 in)

When we passed this citadel, I was instantly taken with the history and the drama of it. This magnificent building had been there since 500 AD but I felt almost certain that no artist had ever even seen it because of its incredibly remote location. In this ever-shrinking world, it was a great privilege for me to be shown places like this before the tour buses and cruise ships discovered them – there is probably a tarmac road leading to the fort now.

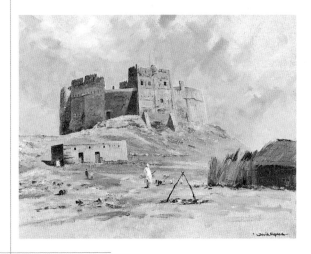

A CLOSER LOOK

Lettering within a painting has to follow the same principles of tonal value used elsewhere. In reality, a sign might be painted in white gloss but within the terms of tonal relationships across the painting as a whole, it is unlikely to be the major highlight. If it is positioned in the middle ground or distance, it's unlikely you'd actually be able to read every word clearly, so it's better to give an impression rather than trying to define each character.

The central figure here is the focal point of the crowd scene. He's deliberately shown as taller than the rest. His height gives him stature, and compositionally he forms the apex of an irregular triangle that draws the eye into the centre of the painting.

The tall figure's relationship with the other people in the crowd is the main narrative drive of the painting. The fact that all eyes are turned towards him adds to the sense of intrigue, but it is left to the viewer to ponder why he commands such attention.

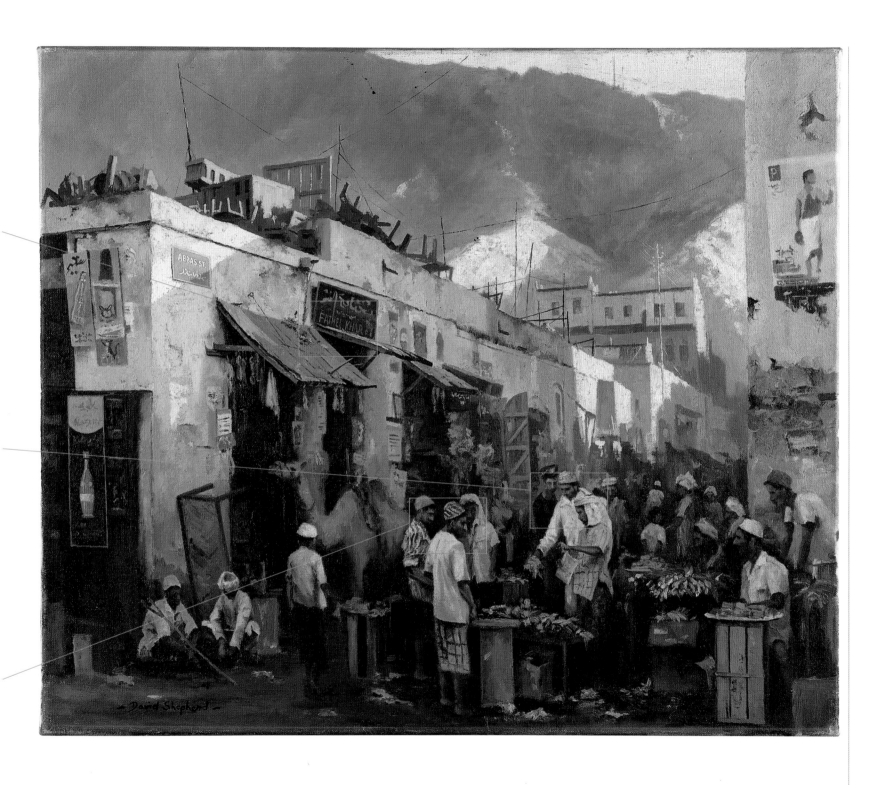

Street Scene in Aden
Oil on canvas
56 × 66 cm (22 × 26 in)

SEIZING THE MOMENT

When I'm travelling around, I often stop and do a quick colour sketch of something that catches my eye. There's a distinct freshness about paintings you do from life in a moment of sudden inspiration.

Few people have ever seen all the sketches I keep stacked up in the studio. They've never been shown anywhere or published in books. I often refer to them as reference material for major works, but mostly they're simply personal reminders and colour records of my emotional reaction to places and moments in time that have struck a chord. For me, that gives them as much value as a finished painting that has gone on to become a sell-out limited edition print.

It's always worth doing quick colour sketches of striking landscape scenes when you come across them. You may choose to work them up later as complete paintings, as I did with my Slave Island sketch below, or use them as background settings for a main subject as I may do with the colour sketch above, painted on the spot in Tangier.

Slave Island
Oil on canvas
41 × 56 cm (16 × 22 in)

I found this marvellous scene while I was waiting for a transport plane home from Aden. I'd gone out hoping to get work painting aircraft for the RAF, but the squadron commanders weren't keen to get involved with artists. When I showed *Slave Island* to the Commander-in-Chief, he was so pleased with it, that he threw a cocktail party and the result was over 30 commissions in one night. It just goes to show that if you're dedicated to painting, you should never give up. You never know when the big break will come.

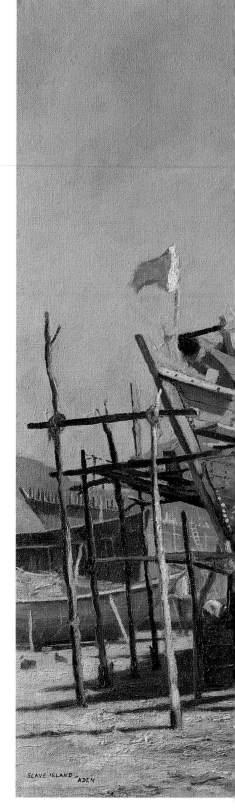

'The Dhow Builders'

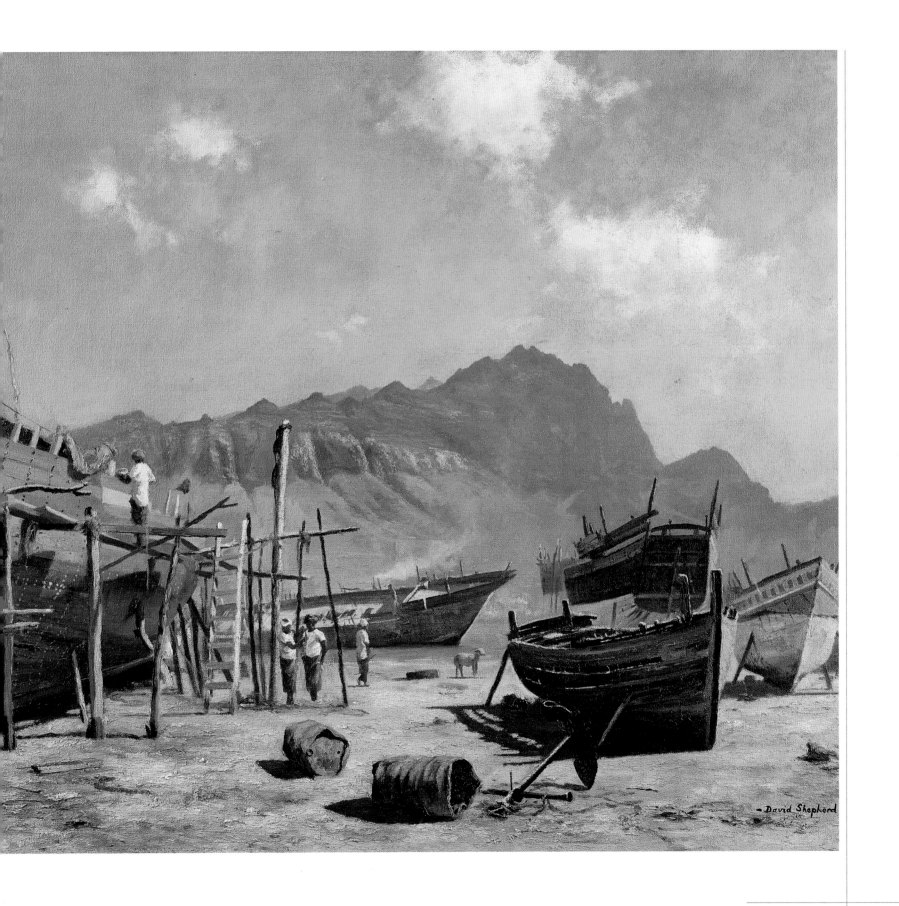

STAYING TRUE TO FORM

It's important to be aware of the natural vegetation in the landscape you're painting. Photographs taken at a safari park in the UK as reference material for a wildlife painting might be fine for the animal subject, but the vegetation in its natural habitat would be very different.

As I have mentioned before, whenever I go anywhere to get new material for a painting, I use a camera but, if possible, sketch from life as well. That way the references are complementary to each other.

Another trick that I was taught by Robin Goodwin was to look at the final completed picture through a hole cut in a piece of paper, checking for accuracy and authenticity in both colour and detail. Make sure you are unable to see the edge of the canvas or the frame – that way you can decide whether you can really feel you are there.

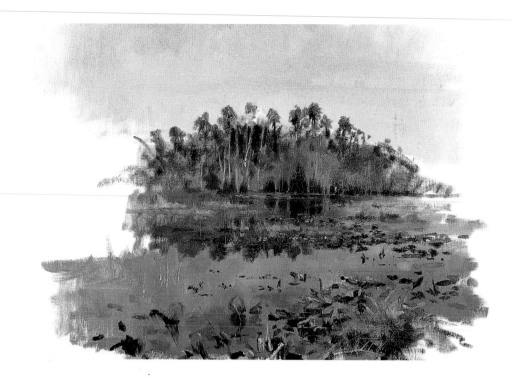

⊙ The water, the rocks and the trees in this small sketch done in the Selous Game Reserve, Tanzania, will provide plenty of reference for a future painting. You never know when a sketch will become the springboard you need to launch a painting.

⊙ Halfway through filming in Florida for Thames TV's *In Search of Wildlife*, the fluid lines of the water's edge and the distant trees in this tranquil corner of the Everglades caught my eye.

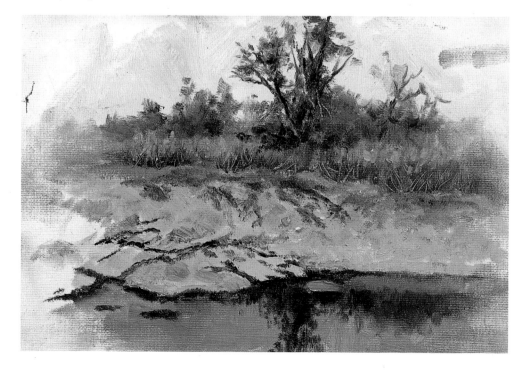

Alligator

Oil on canvas
56 × 38 cm (22 × 15 in)

I used the colour sketch (opposite), done on location in Florida, as the setting for this painting. It may look completed but I am not totally happy with it. It's not just that alligators are not the most commercial of animals to paint; rather, I feel that I could make much more of the texture and colour of the lilies and waterweed.

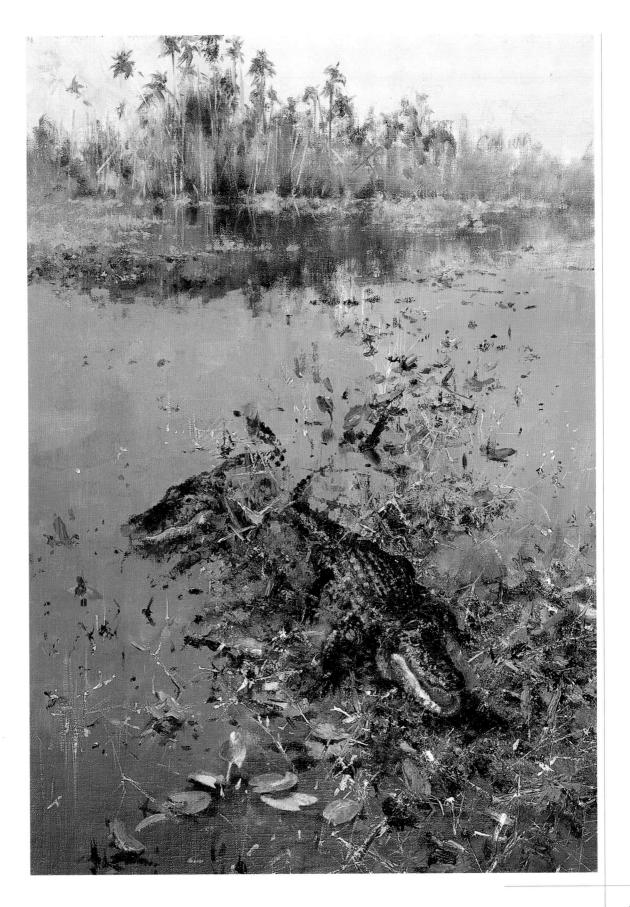

⊕Caught on camera in the Selous Game Reserve in Tanzania.

If you can't actually go and sketch or photograph the real thing, it's worth taking the time and effort to find reference material for a trees such as the baobab. These elephantine trees have spiritual connotations in many parts of the world. According to African folklore they grew from seeds scattered by God as he went back to Heaven after making the Earth. They have such a distinctive upside-down growth pattern and are so prevalent throughout the African game reserves that you can't substitute an oak or a sycamore and hope to get away with it!

⊕Colour sketch of baobab tree.

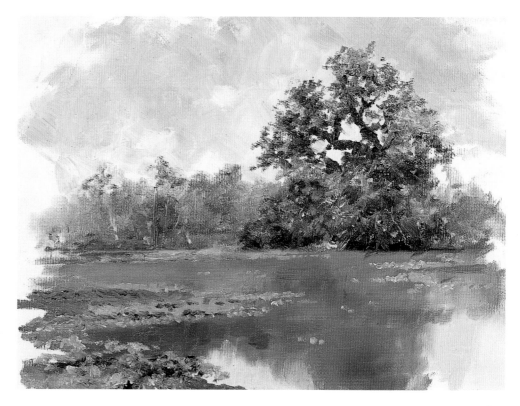

⊕It was the vivid green of the invasive Nile cabbage, seen in the photograph on the left, that I was keen to record. The photo functions well as a backup but the sketch captures the subtleties of the colours.

I spent several wonderful days touring around the Scottish Highlands. Every so often I would jump out of the car and paint the landscape – whatever the weather.

Even on the greyest of days, the hills around Loch Maree were awash with subtle tints of mauves, pinks and greens that I wanted to capture on the spot.

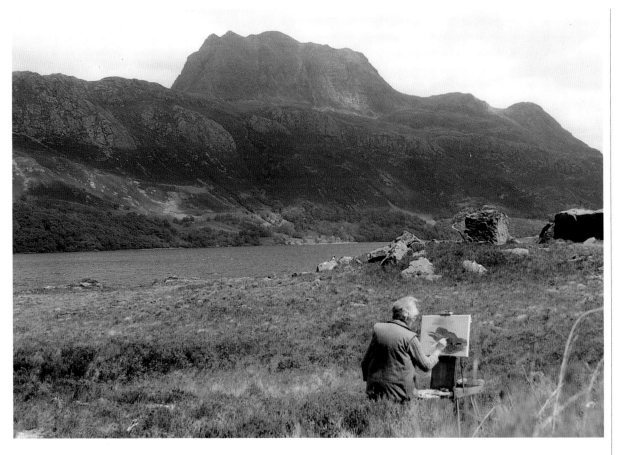

This sketch, painted from life, was an invaluable colour note for my painting *The Prince of Rannoch Moor* (see page 77).

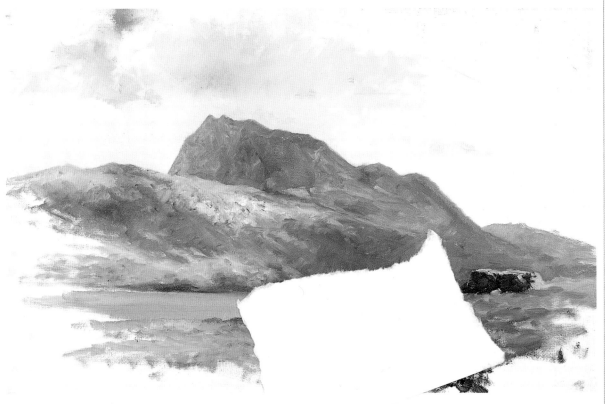

LARGER THAN LIFE

When painting landforms such as rocks, it's especially important to work from life. In a snapshot they might look flat dull grey, but the minerals they're made of are full of colour, and when you look closely at all the lovely mosses and lichens and warm shadows in the crevices, they're bursting with colour.

Nowhere demonstrates better just how exciting rock formations can be to paint than the Grand Canyon. It has everything – glowing colours, interesting shapes – and a vastness that takes your breath away.

I've always been attracted to subjects that are 'larger than life'. Huge powerful elephants, hefty cart-horses, massive old steam engines and here the sheer scale of the Grand Canyon – a mile deep with monumental rock formations and a horizon that stretches away into forever. I was lucky to be there with my easel and paints. All these sketches will be invaluable to me if, one day, I am asked to paint a huge canvas of it.

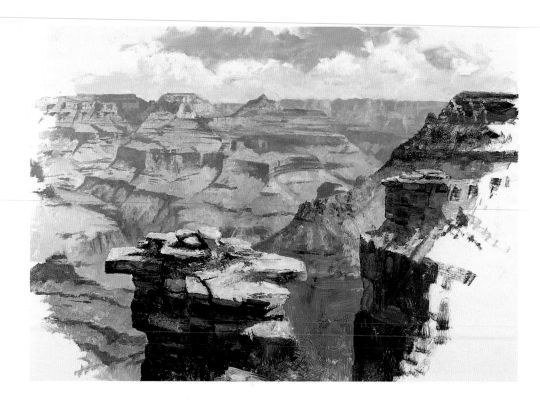

The hard edges and warm shadows in the foreground rock formations create striking three-dimensional shapes against the more muted hazy colours of the receding landscape.

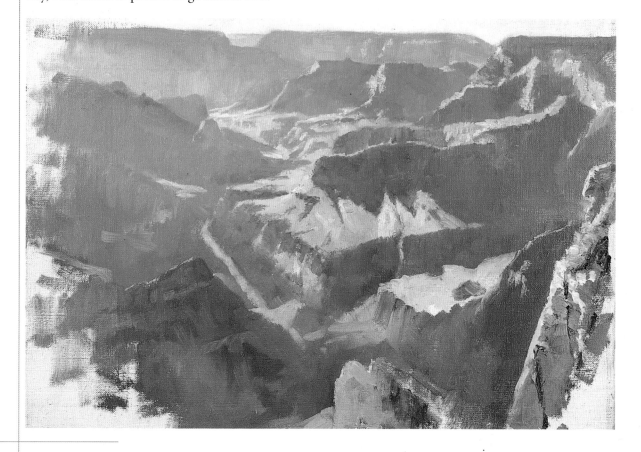

It's like standing on the edge of the world here, as the eye plunges down through sunlight and shadows into the abyss. In the sheer scale of the scene, the great Colorado River looks no more than a stream, threading its way along the valley floor.

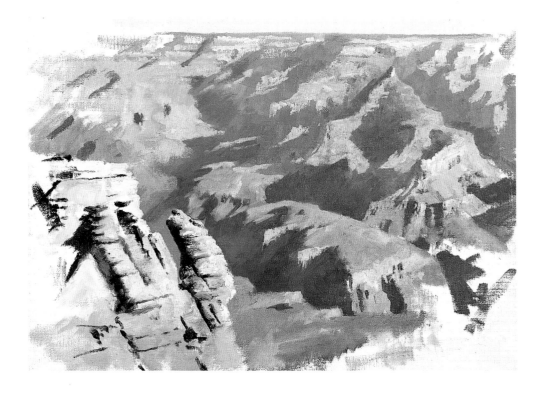

◔ The blue-green carpet of colour over the lower slopes and the hot reds and oranges of the rocky peaks work together as complementary colours. Each makes the other appear more vibrant than they would if seen separately.

◔ When you're confronted by a vast landscape, it's tempting to try to include it all. Choosing just one monumental shape as the focal point lends drama and adds impact.

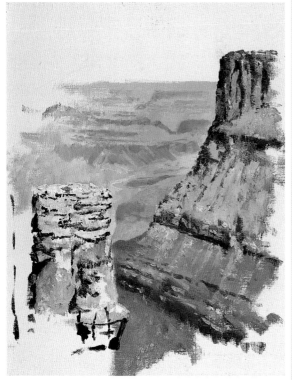

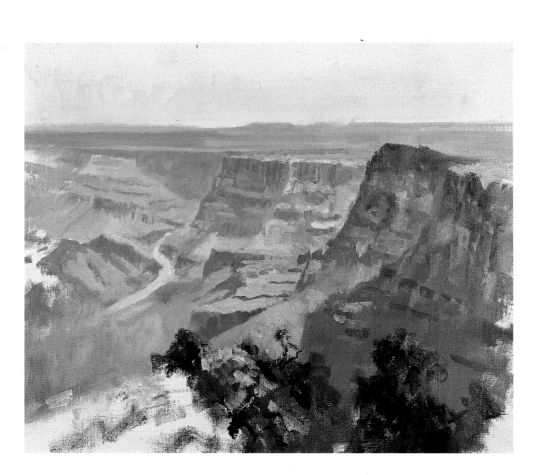

◔ I chose this view for its expression of both depth and distance. The sheer sides of the rocks plummet to the basin beneath, while the flat tops of the cliffs create the edge of a plateau that stretches all the way to the horizon.

OUT OF THE BLUE

Dramatic skies are some of the beautiful features in nature but it is surprising how often they go unnoticed. Indeed, a storm-tossed sky can often be the main focus of interest in a painting.

In some ways a cloudless blue sky is more difficult to paint. With no line or texture to create the perspective and convey the impression of depth and distance, you have to rely on a careful balance of blues.

In the crudest terms, near sky is a warm blue so I use mixes based on French Ultramarine. For a more distant sky, you need a cooler blue such as Cobalt. In the far distance the colour fades even further. This is where I find a pale mix of Coeruleum and Titanium White works well together.

As I work down the painting, I introduce gradations of blues, blending each one thoroughly into the next. The finished result is subtle changes of tones, which are barely perceptible, but are seen as near and far. Again, use heavy textured paint in the foreground, receding into the distance with thinner paint.

Directly above
French Ultramarine + hint of Crimson
Alizarin + Titanium White

Middle Distance
French Ultramarine + Titanium White

Far Middle Distance
Cobalt Blue + Titanium White

Far Distance
Coeruleum + Titanium White

A CLOSER LOOK

I don't know why so many people find boats difficult to paint. They're just shapes. Paint what you see, not what you think is there.

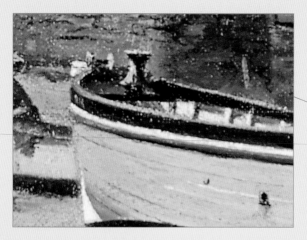

In reality the driftwood was strewn around randomly, but as an artist you can alter reality to suit your composition. The angling of all the main branches was contrived to lead the eye to the old fishermen sitting in the sun, but it mustn't look as if it is.

Texture and line work together to make the shingle beach slope uphill. Thick textured paint for the wood and rubbish in the foreground brings the beach forward. As the eye moves up the painting, the horizontals on the stone slipway become less distinct and shrink closer together.

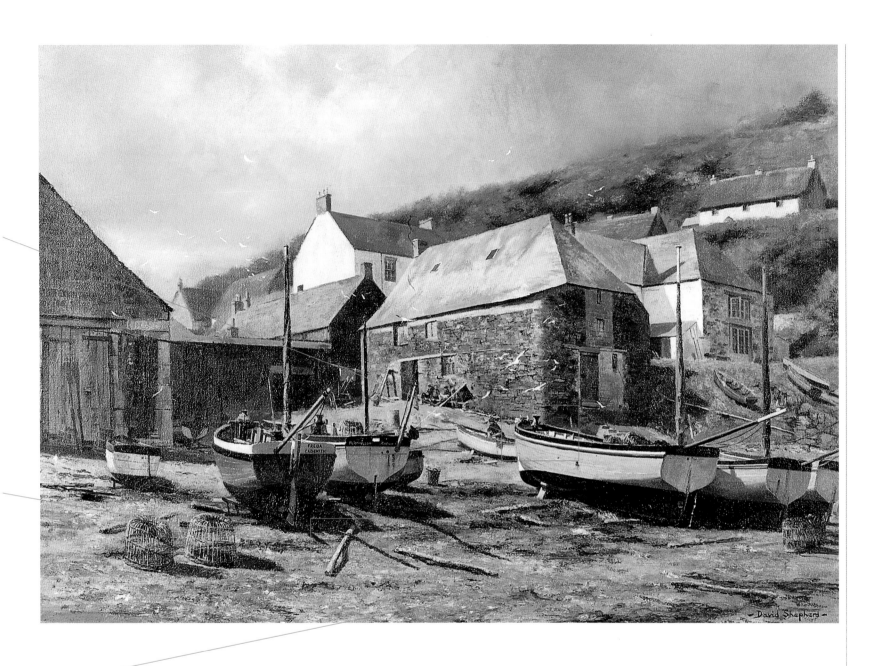

Cadgwith
Oil on canvas
51 × 71 cm (20 × 28 in)

STEP-BY-STEP DEMONSTRATION: Elm Tree

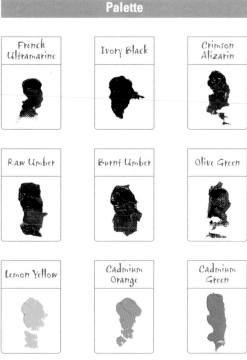

Palette

French Ultramarine

Ivory Black

Crimson Alizarin

Raw Umber

Burnt Umber

Olive Green

Lemon Yellow

Cadmium Orange

Cadmium Green

It was such a tragedy when Dutch elm disease virtually wiped out this wonderful tree, with its distinctive fan-shaped canopy and mass of twigs. I'm very glad I photographed so many of them before they disappeared. Here, I'm working from a faded photo that I took years ago. My aim is to paint a tree that's full of life and movement, touched here and there by sunlight shining through chinks in the clouds.

Painting with David Shepherd

STEP ONE My first step was to decide on the position of the tree and then to block in the sky, with a large No 10 flat hog brush. The base colours were French Ultramarine and Titanium White, while Ivory Black was added to create the storm clouds. A suspicion of Crimson Alizarin, which was blended in towards the horizon, added an atmosphere of drama. This is a very powerful colour so it has to be used sparingly or it will dominate the sky.

The sky area around the tree itself is almost white, to create a crisp contrast which throws the subject forward. I left the sky colour to dry completely before drawing a light outline of the tree in charcoal.

STEP TWO I sketched in the skeleton of the tree with light brush strokes. The basic colours used were shades of Raw Umber and Burnt Umber, lightened with Titanium White. Olive Green was used for some of the mossy covering on the trunk and the sunlit areas were created with Lemon Yellow.

While establishing the profile of the tree, I took care not to make the branches too symmetrical as they grew up and out from the trunk, to avoid creating a regular 'fountain effect'. Once the outline was in place, I started to build contours in the trunk, modelling the warm shaded areas with Burnt Umber.

An elm tree trunk has a characteristic 'fluffy' outline which I produced here by catching a sparing amount of neat Raw Umber on a wide bone-dry brush, lightly flicking it across the surface so the pigment caught only on the top grain of the canvas. Another technique is to pull some of the wet paint out from the trunk with a dry brush to make the fine twigs that come out above the browse line – formed when cattle have been grazing the lower branches.

When I came to sketch in the canopy, I kept the brush strokes very light in order to retain its airy delicacy.

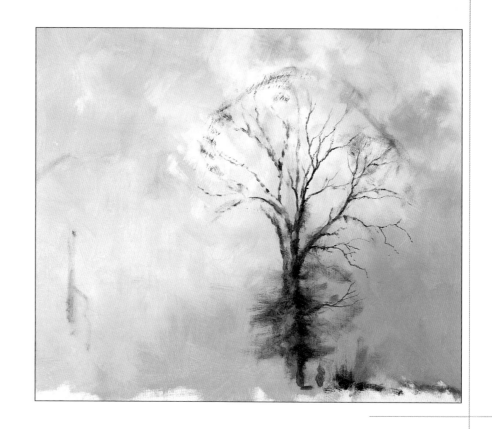

STEP THREE I used the same dry brushwork for the fine tracery of twigs along the outer edge of the canopy. Varying the pressure of the brush gave it a less uniform, more realistic look. By constantly changing the angle of the brush I avoided painting straight lines, maintaining a more natural effect.

As I started to put in more defined twigs, I switched to a rigger brush and made the paint more fluid by adding linseed oil. To create the sunlit areas, I used a mix of Lemon Yellow, Raw Umber and Cadmium Orange and picked out the brightest foreground twigs in pure Lemon Yellow.

The big spread of the canopy was established next. While working on this, I was careful to bear in mind that each branch has to grow from another, as in nature, and that the shape should be balanced, without being too symmetrical.

Elm trees were a favourite nesting place for rooks so I created a rookery in the top of the canopy with dabs of Raw Umber. I used light irregular 'V' shapes for the flight of rooks, which helps to pull the elm tree over to the left visually and to balance the composition.

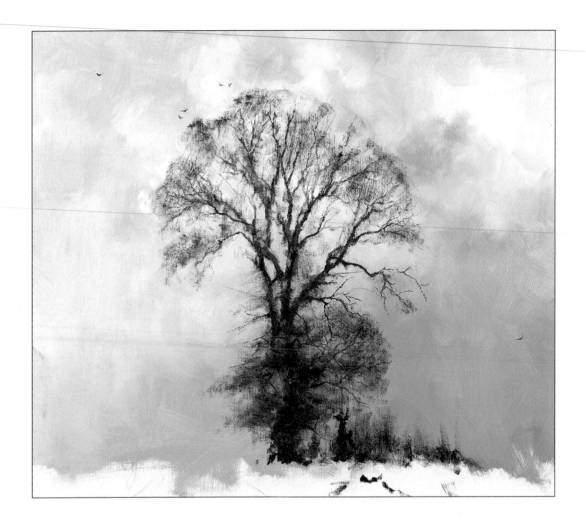

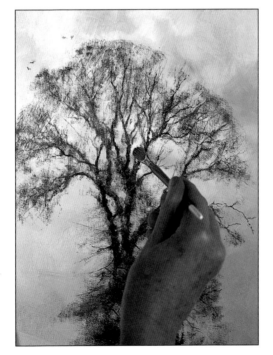

Once the tree was in place, I lightened the sky between the branches with carefully applied touches of Titanium White, toned down to an off-white by adding the merest trace of French Ultramarine and Ivory Black.

Painting with ~David Shepherd~

STEP FOUR I strengthened the trunk with deeper warm shadows of thick Raw Umber but to add more warmth and colour into the painting I used this together with Lemon Yellow. I have found that this combination works well with the colour of bark on elm trees. To portray the feel of creeping ivy, I mixed French Ultramarine and Cadmium Green. I then added more pure Lemon Yellow in the foreground, turning the brush round and using the pointed end of the handle to scratch into the wet paint for the thinnest sunlit highlights.

I painted the ground around the tree in thick paint, applied with a brush that had been beaten to splay the bristles. I really enjoy this part of the painting process, plastering on all the mixed colours still on the palette. It creates a textured tangle of growth around the base of the tree which helps to give the painting a three-dimensional sense, while using colours already existing in the painting to pull the undergrowth and the tree together.

The broken branch on the ground, painted in Burnt Umber, helps draw the eye up to the tree and the addition of the fence posts in Lemon Yellow, toned down with Burnt Umber, gives a sense of scale and extra foreground interest.

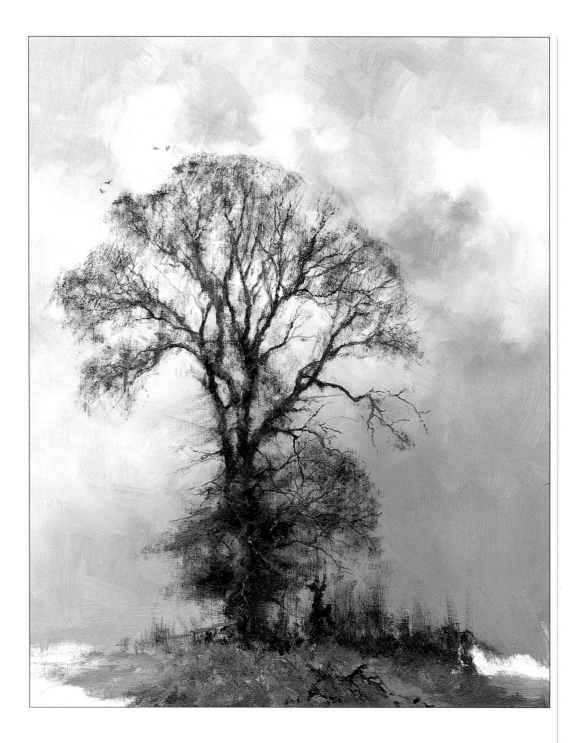

INTO THE GREEN

With such lovely lush and fertile countryside, green is naturally the predominant colour in any traditional English landscape. Sunlight and shadow on green grass is wickedly difficult to paint. The rough dirty grasses of the African savannah are much easier.

Although there are many different greens available in ready-mixed oil colours, I have only bright Cadmium Green and muted Olive Green on my basic palette. The rest I prefer to mix myself, based either on those tube greens or on a combination of blues and yellows.

Greens in the distance naturally appear paler and less distinct than the greens that feature in the foreground. To put it another way, distant greens are cool, while near greens are warmer so it makes sense to mix cool blues with cool yellows for distant greens and hot blues with hot yellows for bright and punchy foreground green.

Cool Cobalt Blue mixed with Yellow Ochre and Titanium White makes a recessive muted green for distant vegetation. Warm French Ultramarine mixed with brilliant Cadmium Yellow and Titanium White makes a strong dominant green for foreground work.

Cobalt + Yellow Ochre + Titanium White = Cool distant green

French Ultramarine + Cadmium Yellow + Titanium White = Warm near green

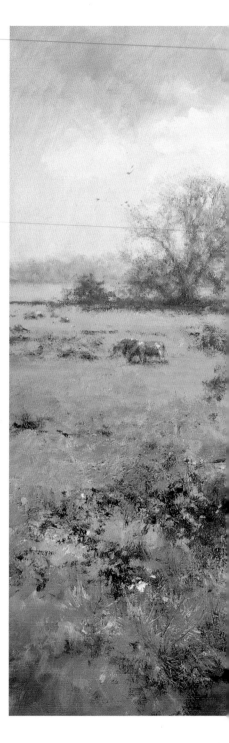

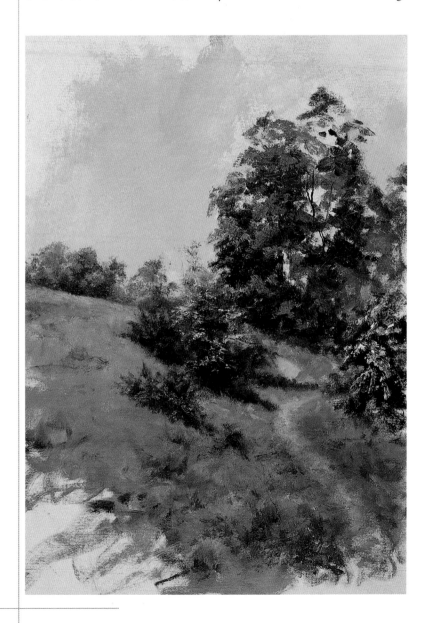

Colour sketch of tree and path.

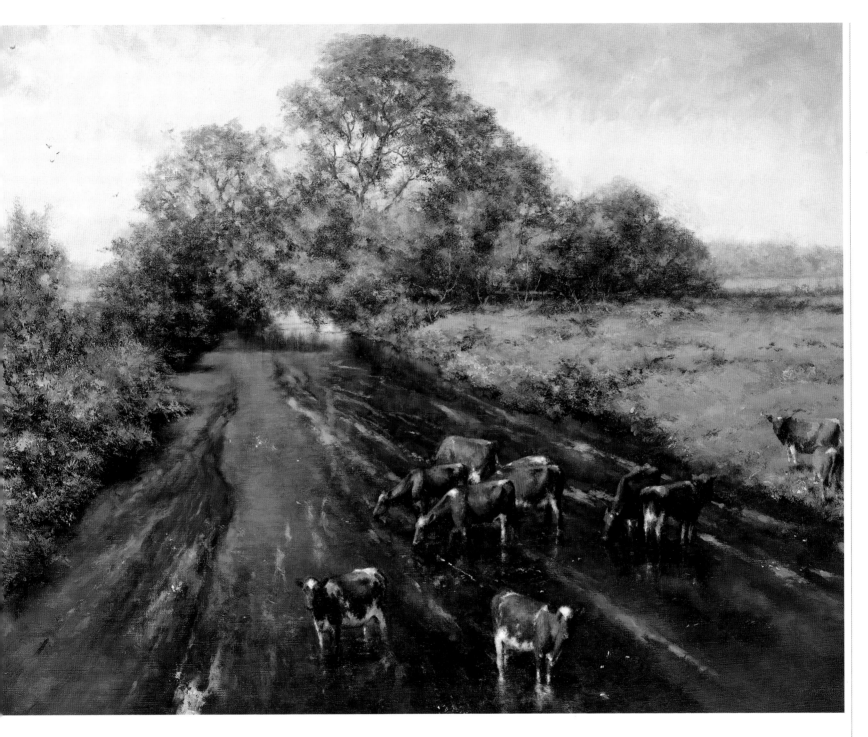

An English Summer
Oil on canvas
51 × 86 cm (20 × 34 in)

This was based on an actual view near Guildford, where I was attracted to the wonderful colours in the water weed. For the most part the river is painted in mixes of Light Red and Lemon Yellow, with touches of blue only where the sky is reflected in the water.

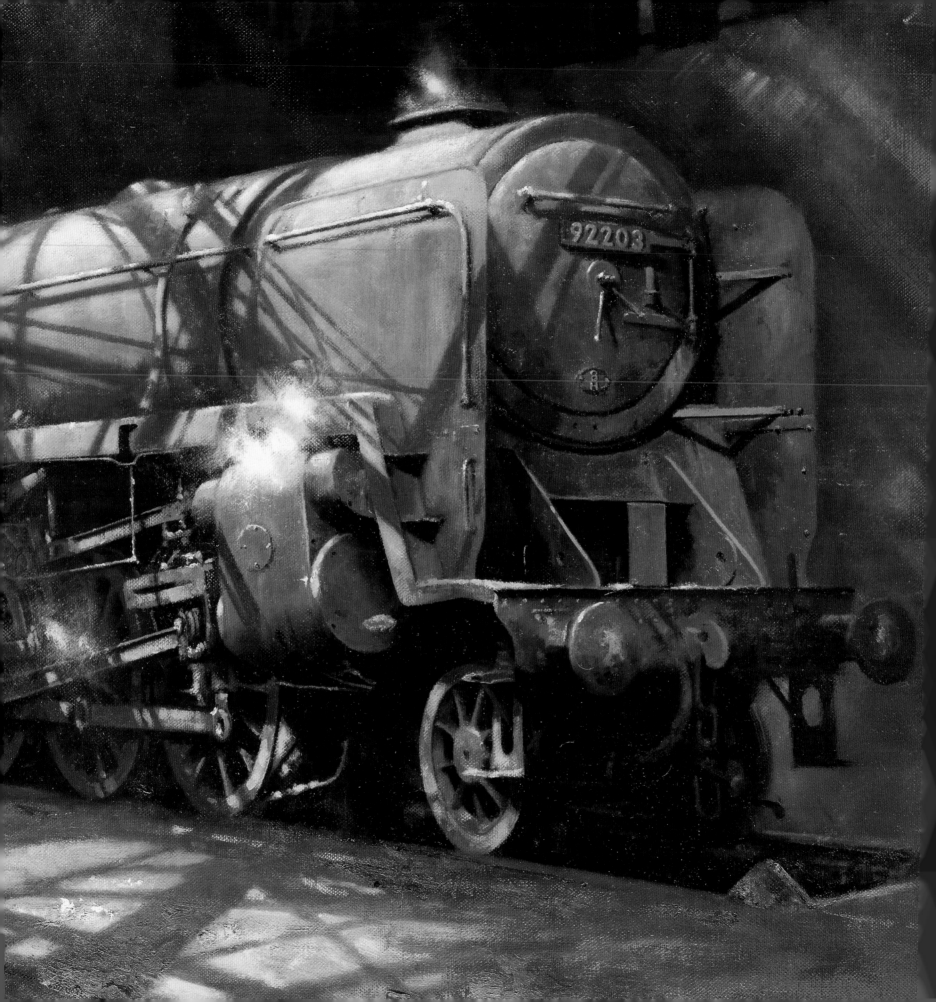

TRAINS, BOATS AND PLANES

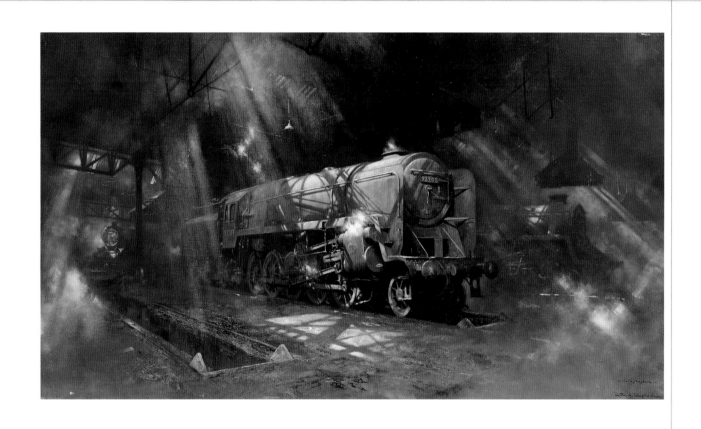

CAPTURING THE LOST AGE OF STEAM

As a child I always preferred to watch trains go by than build sand castles, and my passion for steam engines was nurtured by my father, who was a fanatic. Steam, like animals, was in my blood.

Throughout my life, I've always been excited by anything that is large and dramatic. I get the same thrill from seeing a giant steam engine as I do from a huge bull elephant. In their way, they both need saving.

If I had to choose my favourite painting subject, it would be, by a short head, steam locomotives and the smoky steam sheds of the past. If railways had been around in Rembrandt's time, I am sure he would have loved the sombre colours and the unique atmosphere found in these places. The composer Dvorak loved steam engines. When he wanted inspiration for his New World Symphony, I am told he rushed down to Willesden loco sheds in London – a lovely thought anyway!

For the artist there were wonderful harmonies to be found among the cool browns, greys and mauves of soot-caked engines, as well as the glimpses of brilliant light where dripping oil caught in the sunlight and the occasional wisp of steam rising into the darkness overhead.

For a steam enthusiast it was a heart-rending sight, witnessing the demise of these great locomotives. The steam age didn't go out in a blaze of glory – it went out in neglect, filth and degradation. During the final days of steam in the mid 1960s, I spent hours and hours in the old sheds, sketching, taking photographs and painting like a demon in an effort to capture as much as I could before it was too late.

previous spread
The Artist's Own Locomotive
Oil on canvas
76 × 142 cm (30 × 56 in)

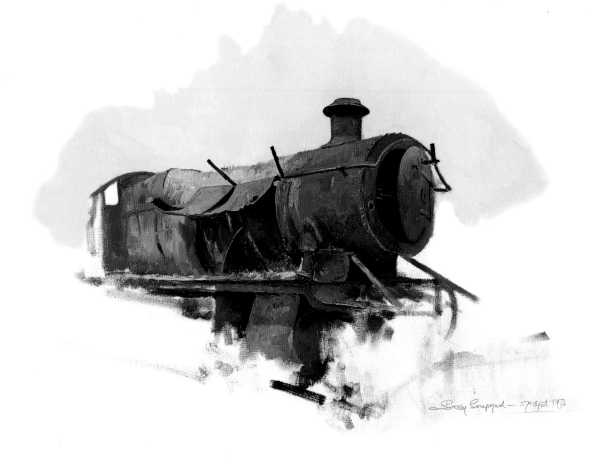

Rusty Engine, Sketch at Barry Scrapyard in Wales
Oil on canvas
51 × 71 cm (20 × 28 in)

The carcass of this engine created great shapes, with areas of contrasting highlight and deep shadows. The reds, golds and oranges of the rust were more exciting to paint than its original shiny green paint would have been.

I used thick paint, daubed on to replicate the texture of rust. The basic colour is Light Red, a gentler red, which I worked into with Yellow Ochre, Cadmium Yellow and touches of Ivory Black.

The pale sky was a considered choice. A darker tone of blue would have detracted from the main subject. I was being filmed working on this quick cameo sketch, and think that if I had completed the painting it would have lost some of that freshness.

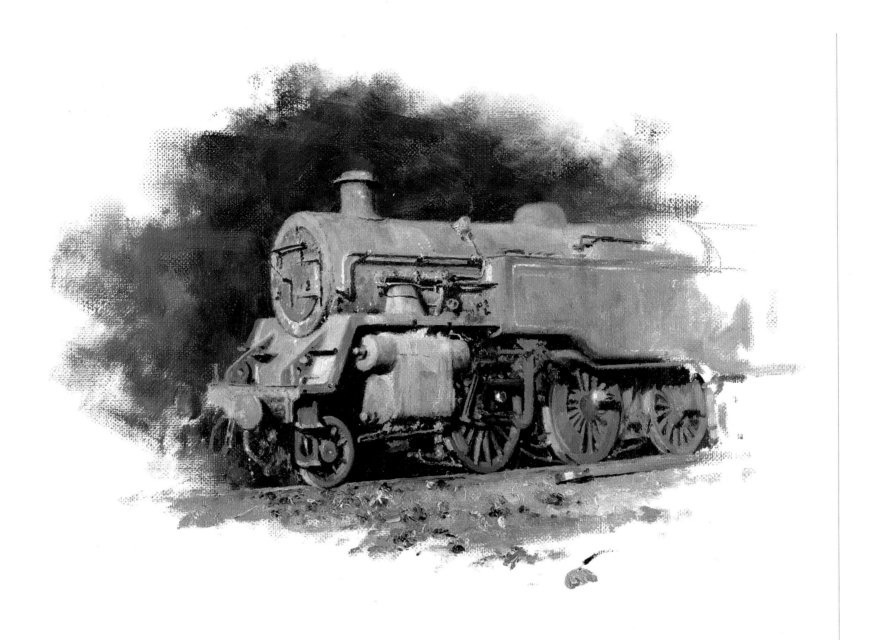

**BR Tank Locomotive at Nine Elms Shed,
near Waterloo**
Oil on canvas
30 × 51 cm (12 × 20 in)

This was a relatively new engine but it was already out of service
and falling into disrepair. From an enthusiast's point of view, it
was sad to see the rust creeping onto the smoke-box and eating
into the original paintwork. But, from an artist's perspective, it
was a wonderful opportunity to create effects by applying colour
over colour, re-creating the layers of paint, filth and rust – much
more exciting than painting a clean engine.

PUT YOURSELF ON THE SPOT

These lightning sketches were painted at Guilford and at Nine Elms, near Waterloo, now part of Covent Garden. They were only half-hour colour notes, painted in the heat of the moment as possible reference material for future paintings – and each one is worth 5,000 colour photos to me. As I have mentioned earlier, an artist's eye detects colours within colours that may be lost in a photograph.

It was the greatest fun recording the subtlety of colours. Dirt and filth, yes, but glorious colours in all that grime – warm browns and reds. I worked experimentally, trying each colour on the paint that was already on the canvas, and allowing one colour to glow through another.

Working sketches for Last Hours at Nine Elms
Oil on canvas
51 × 61 cm (20 × 24 in)

I painted this sketch in appalling conditions, working quickly because the locomotive was going to the scrapyard the next day. Being so close, I only had to lower my eyeline a matter of inches and all the perspectives changed. A particular difficulty was to paint two circles at different angles, the wheels from one angle and the boiler from another.

***Bullied Pacific* at Nine Elms**
Oil on canvas
51 × 76 cm (20 × 30 in)

I was up on the roof painting this and suddenly spotted a flash of blue from the sky reflected in a pool of water that had gathered in a dent in the bodywork. It formed the perfect counterbalance of colour against the warm lights and darks in the rest of the painting – and one I'd never have thought of if I hadn't seen it. When you're working from life, you're much more attuned to this sort of detail, which can literally make the painting.

It might not be the most glamorous photograph in the world, but reference material like this is invaluable. The cool blue of the small puddle and the warm brown of the larger pool add splashes of complementary colour, which break the blandness of the muddy area beside the tracks. Colourful details like this can add such a lot of interest to the foreground in a railway painting.

Guilford

Oil on canvas
41 × 51 cm (16 × 20 in)

The absence of detail in the background focuses attention on the engine, emerging into sunlight. The solid dark colours of the inside of the railway shed bring the subject forward, and the deep shadow slanting across the bodywork adds an element of drama, as well as emphasizing the shape of the boiler. In a monochromatic study like this, tonal values are paramount. In a finished painting, I would have softened the tone of the shed's interior so that the darkest tones were on the engine itself, not in the background.

Steam at York Running Sheds

Oil on canvas
41 × 56 cm (16 × 22 in)

I found a marvellous perspective on the turntable, where the tracks, railings and slanting shadows converged on the locomotive. The nearer left-hand sunlit side of the shed is painted in warmer tones than the more distant deeper reaches of the shed.

The tonal balance between the engine and the background is more carefully considered here, with the darkest tones falling on the engine, which forms the focus of the picture.

When you're doing a mainly monochromatic painting, the introduction of a touch of colour can be very effective. It should be used sparingly, and relate to the main subject area of the painting, otherwise it will be a distraction. The yellow noticeboard on the turntable gave me just what I wanted.

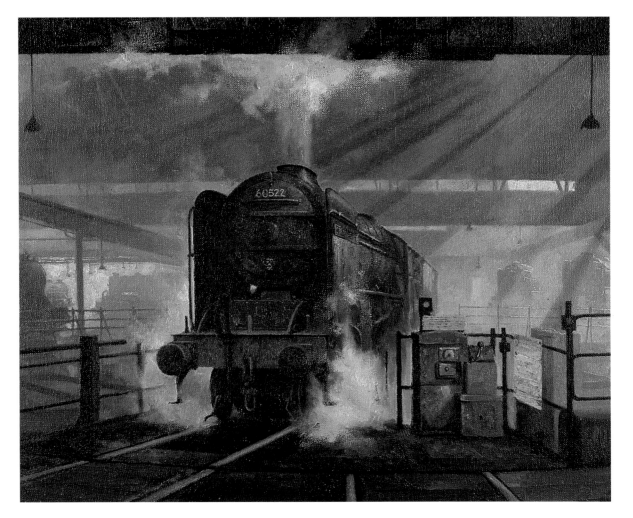

PAINTING IN THE STEAM SHEDS

Back in the 1960s, one endangered species saved another. My elephant paintings were doing well and, from the proceeds of a show in New York, I managed to buy two steam engines, the *Green Knight* and *Black Prince*.

Like so many enthusiasts feverishly trying to stop these giants of steam from being broken up for scrap, I hardly gave a thought to where I'd put them. Once again, in a roundabout way, art came to the rescue and found them a resting place. When I mentioned the problem to one of the colonels who had commissioned my painting of Christ for the Bordon Memorial Garrison Church (see page 131), he suggested nearby Longmoor, which had an extensive military railway system and an old Nissen hut to house them.

It took a further 11 months to persuade British Rail bureaucrats to allow us to drive them down from Crewe in full glory under their own steam, rather than having them towed ignominiously by diesel. It was a very special moment as we steamed through my then hometown of Godalming, and on to Longmoor.

A CLOSER LOOK

Painting engine smoke is similar to painting the dust that elephants raise – after all there is virtually no substance to either. In order to portray this, I use a well-thinned mix of Ivory Black, Titanium White and Burnt Umber for a warm grey. I rub it onto the canvas with a big brush and blend well with a finger. It can be painted wet into a wet sky or dry into a dry sky.

Perspective of colour helps to create a three-dimensional effect. Here, the signal is the nearest object to the viewer, so it is painted in dark solid colour. The next 'layer' is the train, rendered in mid tones, while the softest coolest tones are reserved for the distant power station and cooling tower. Creating a three-dimensional sense is as simple as that; use heavy, strong colours in the foreground which lessen as one recedes into the distance.

The limescale caused by water from the boiler and the escaping steam, coming fresh from the engine, provided an opportunity for clean white. As the highest, brightest tone in the whole painting, it naturally draws the eye to the heart of the painting, and also emphasizes the sad state in which our great steam heritage ended up in the late 1960s.

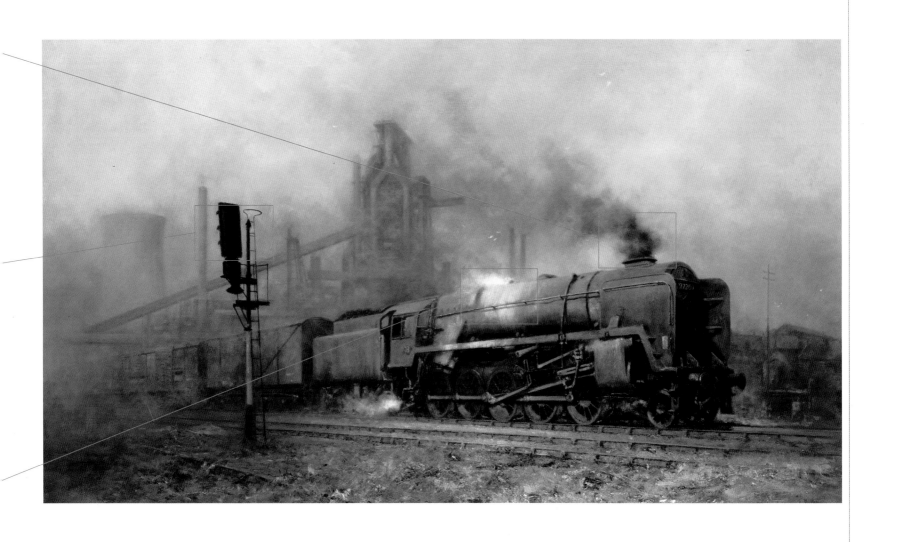

Heavy Freight 67 – _Black Prince_
Oil on canvas
36 × 61 cm (14 × 24 in)

DEALING WITH DETAIL

Artists should always be enthusiastic about the subjects they paint. In my case, having grown up during the Second World War, I have an affinity with this era which has certainly been beneficial when painting for the services.

Although I love the subject matter, it leaves little room for artistic licence. Whether you're painting a plane, a ship or a tank, the services' primary concern is technical accuracy. Only when they're satisfied with that do they stand back and regard it as a work of art.

My challenge when trying to avoid rigid photo-realism is to give the impression that every turret and rivet is there, without actually painting each one in detail. I tend to leave out detail progressively as the object recedes to create a three-dimensional feeling. As a rule of thumb, if the detail can't be seen clearly with the naked eye, you can simply allude to it with a brushmark. The other limitation on the artist

painting to a tight brief is resisting the temptation to include elements that aren't there in the cause of artistic effect or compositional balance.

Of all the services, the Royal Navy is probably the most demanding. My painting of *Ark Royal* had to be scrutinized by the captain before it went to print and he seized on the smallest details – such as tiny touches of red for the intake covers on the jet pipes. They had to be painted out because the engines would have been running at the time!

An integral part of any painting of a ship is the sea itself, which requires equally careful observation. Waves have defined shapes and perspective. A bow wave, for example, has a particular shape – you can't just splash on a load of foam and hope it will look right.

Ark Royal, **Turning into Wind**
Oil on canvas
48 × 91 cm (19 × 36 in)

I wanted the painting of *Ark Royal* to depict a great aircraft carrier cutting through the sea and turning into wind, which they have to do to launch the aircraft. Although I'd spent days aboard studying every detail as she returned home on her final journey, she was too old to get up enough speed to create a decent bow wave. I was, however, given the opportunity to witness just that with another aircraft carrier. I felt very flattered!

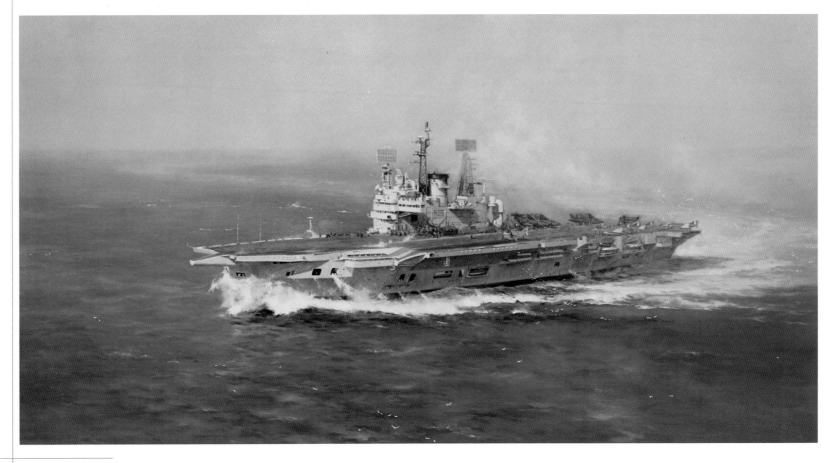

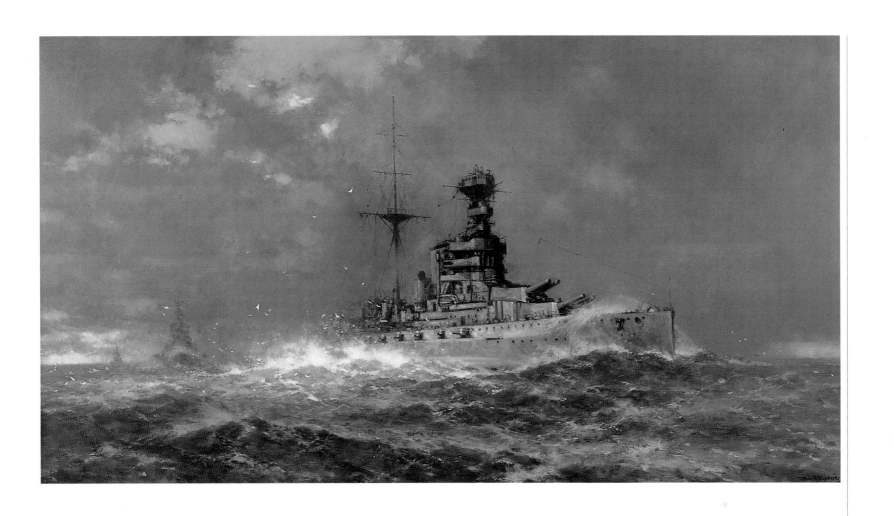

Glory Days
Oil on canvas
61 × 91 cm (24 × 36 in)

I would never claim to be a marine artist and this is my only painting of a truly rough sea. I loved doing it, however, because I wanted to show Britain as a great maritime nation. As I have mentioned, extreme accuracy is imperative in such a subject, and I was lucky to be allowed to use a model from the National Maritime Museum at Greenwich for reference.

SETTING THE SCENE

I have always had a particular affection for the Royal Air Force, not only because of the place they have in my wartime childhood memories, but also because it was the RAF that started my career as a wildlife artist.

After the success of my painting *Tiger Fire* for the World Wildlife Fund in 1977, the RAF Benevolent Fund asked if I could pull off a repeat performance for them. They left the choice of aircraft to me – and as far as I was concerned there could only be one, the Lancaster.

I could have gone to the Imperial War Museum and studied photographs of Lancasters, but that's not my way of doing things – and not half as much fun as flying in one.

After an unforgettable trip in a Lancaster bomber, I spent three days sketching the *City of Lincoln*, the last surviving Lancaster in full flying order. We had the support of the 39-45 Military Vehicle Group, together with a vicar who produced a 1943 Hillman pick-up and a farmer who loaned us his vehicle, on the right-hand side of the painting, from which he used to feed his pigs. The RAF found some bombs on a genuine trolley, a tow tractor, a motor bike and a 1940s bicycle. Over a four-day period, I moved things around until I had an authentic composition.

The Lancaster was standing in front of a hangar full of Phantom jets, which I replaced with a stand of elm trees in the painting, as they were more in keeping with the period. They also provided a strong triangular backdrop to the main subject, and lent complementary height to the mainly linear grouping of the aircraft and associated vehicles.

To complete the scene, I wanted to create the effect of a winter's evening after a shower of rain. The station commander sent the airport fire tender to deposit 500 gallons of water and create lots of mud, which I was told was true to the memory of Second World War bomber stations.

The outcome was *Winter of 43; Somewhere in England*, which raised £95,000 for the RAF Benevolent Fund.

A CLOSER LOOK

The positioning of the highest white tones on the nose of the aircraft naturally draw the eye to the main subject, but there was a practical reason for this too. I discovered that some potential buyers among ex-Lancaster crew were interested only in a print of the actual plane they had flown in. By letting the sun catch the nose, and by placing the oiler in front of the fuselage, I managed to obscure the plane's identification letters.

The decision to flood the runway wasn't just taken to add narrative to the painting. It also offered the opportunity to include strong vertical reflections, which counterbalanced the strong linear horizontal composition of the major elements.

The accuracy required when painting an aircraft or any other military subject means that the artist is restrained from using oil paint too generously. The mud in the painting therefore gave me a welcome opportunity to relax and be more expressive.

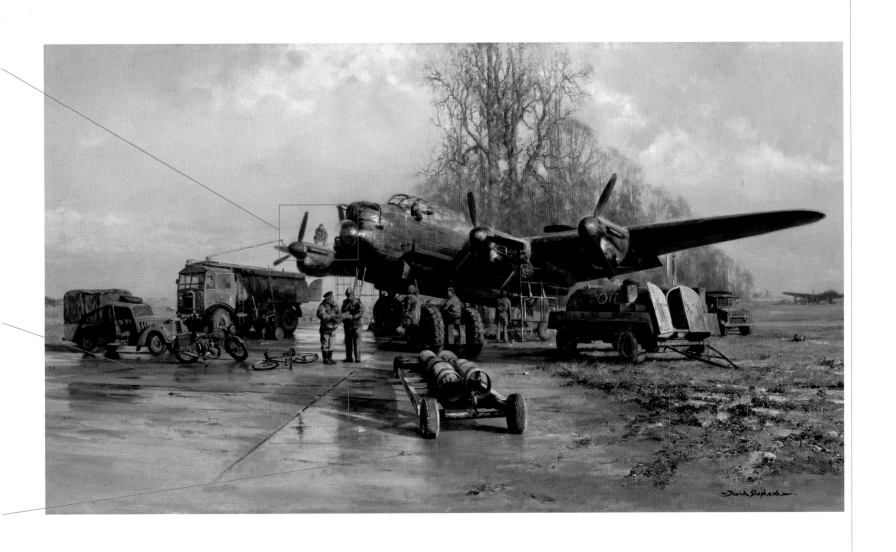

Winter of 43; Somewhere in England
Oil on canvas
61 × 86 cm (24 × 34 in)

A SENSE OF MOVEMENT

The Army Air Corps flew me out to Malaya for
the painting that I did for them in the 1960s.
They wanted a picture of an Auster-9 landing on
a jungle air strip. As a runway, it was pretty
overgrown and there was even a bullock grazing
on it. I climbed out and asked the pilot to take off
and come in again. I didn't want a dead flat
landing, but one with the wings tipped to add to
the sense of movement and potential danger. He
obliged several times while I took photographs –
and kept an eye on the bullock!

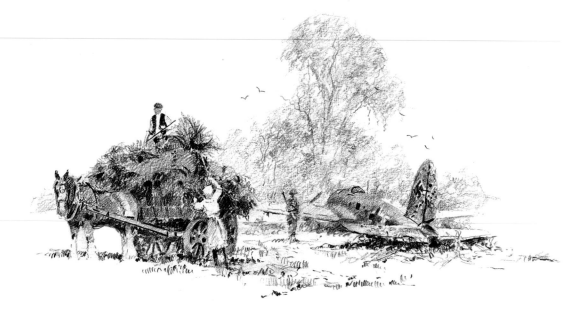

Crashed Heinkel in a Cornfield
Sketch

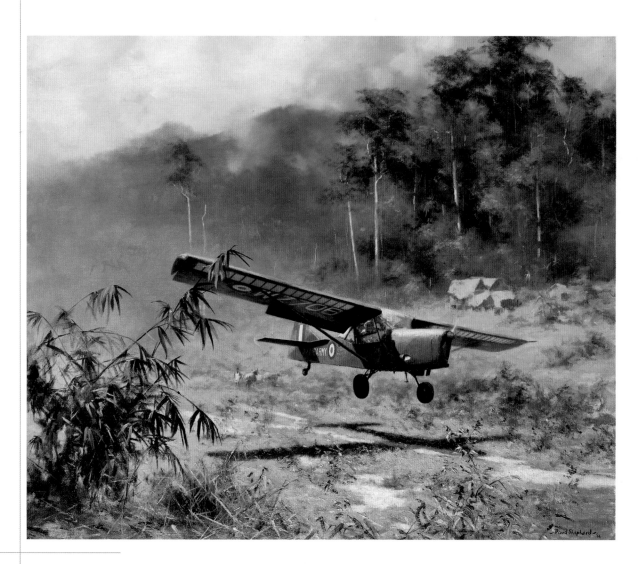

Auster-9 in Malaya
Oil on canvas
46 × 51 cm (18 × 20 in)

The landscape around the plane is an
expression of the local countryside, but
the detail was invented to enhance the
composition. The misty trees over on the
right give an impression of distance and
lend an air of mystery. The sharp white
trunks of the background trees provide
strong verticals that create a visual
tension against the predominant
diagonal lines in the main subject. They
also help lead the eye down to the
Auster – as does the longest branch on
the bush in the bottom corner. The deep
shadow cast by the plane adds interest
to the foreground and intensifies the
narrative drive.

Q for Queenie – Late of *The Dambusters*

Oil on canvas
51 × 76 cm (20 × 30 in)

Not having so much commissioned work in 1955, I could indulge myself in this painting of the war-weary Lancaster on the runway. It is always helpful to have an emotional involvement with the subject. Shortly after painting this it was flown away to a scrapyard. The image was later used in newsreels by the old Pathé Pictorial, who came to one of my exhibitions and filmed the painting in detail, creating the most amazing impression of the aircraft coming towards you.

Crashed Heinkel

Oil on canvas
25 × 46 cm (10 × 18 in)

My interest in Heinkels goes back to my childhood and the sight of a crashed Heinkel is one of my earliest memories. I liked the idea of painting the contrast here; the peace and tranquility of the haycart and the aggressive warfare represented by the German aircraft in the field.

PAINTING THE PAST

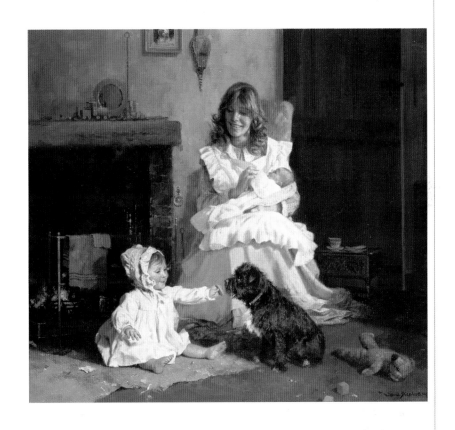

A SENSE OF HISTORY

When you're trying to create a sense of history, attention to detail is very important. Everything in the painting must be authentic. It helps to create the atmosphere – and you can bet if you try to get away with something that's out of period, the painting won't look true to its time. Someone will always spot it.

I live in the past in many ways and am desperately saddened to see how life has changed for the worse. I feel passionately about many of the changes that modern life has brought. I have so many chips on my shoulder I can hardly walk!

Normally I like to take my own reference shots, but for narrative period paintings, I have to be sure that every detail is correct so I compose the image as a set piece and have it photographed by a professional. My challenge is to take the image further than the camera can. An artist can recreate the past in a way the camera can't.

I'm very interested in narrative in paintings even though I hardly ever read fiction. When I was asked on Desert Island Discs which book I'd take, I said Beatrix Potter. Living in the past again, I suppose. Nostalgia is escapism for me. So many books today are full of violence and the unpleasant side of everyday life.

We dressed the woman in *Cottage Companions* in a mobcap to help create the atmosphere and set up the scene in the dining room of our old house in Hascombe. The dog I painted here is Muffin, our old bearded collie, who is asking for his 'walkies'.

When I was preparing for this painting, we did some research and discovered that many families used to sit right inside the inglenook fireplace itself and draw the curtains across to retain the heat. The houses used to be so cold in those days, partly because they only had straw on the floor. Apparently, on occasions, they would also have a little ruffle of curtain material on the beam above the fireplace. Avril made something similar and, when we were fastening it onto the beam, we found a little piece of the old original fabric going back all those years. It may have been there since 1500. I find that it is the little details like this that make a painting memorable and give it heart.

previous spread
Biscuits
Oil on canvas
56 × 61 cm (22 × 24 in)

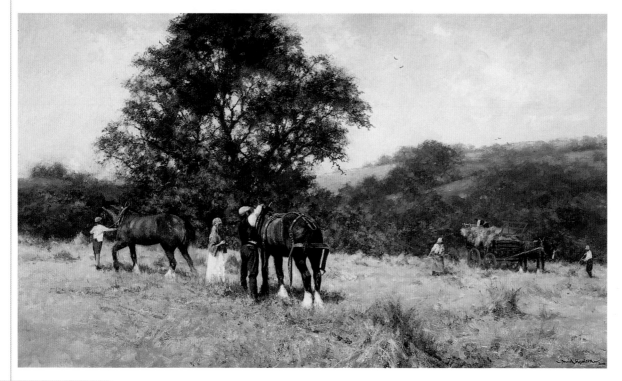

Summertime
Oil on canvas
58 × 96.5 cm (23 × 38 in)

This painting turns the clock back to horsepower and to the era when corn was stacked by hand. There's nothing romantic about the way they do it now – with tractors and black plastic bales. I love painting heavy horses, wonderfully affectionate animals with fluffy legs.

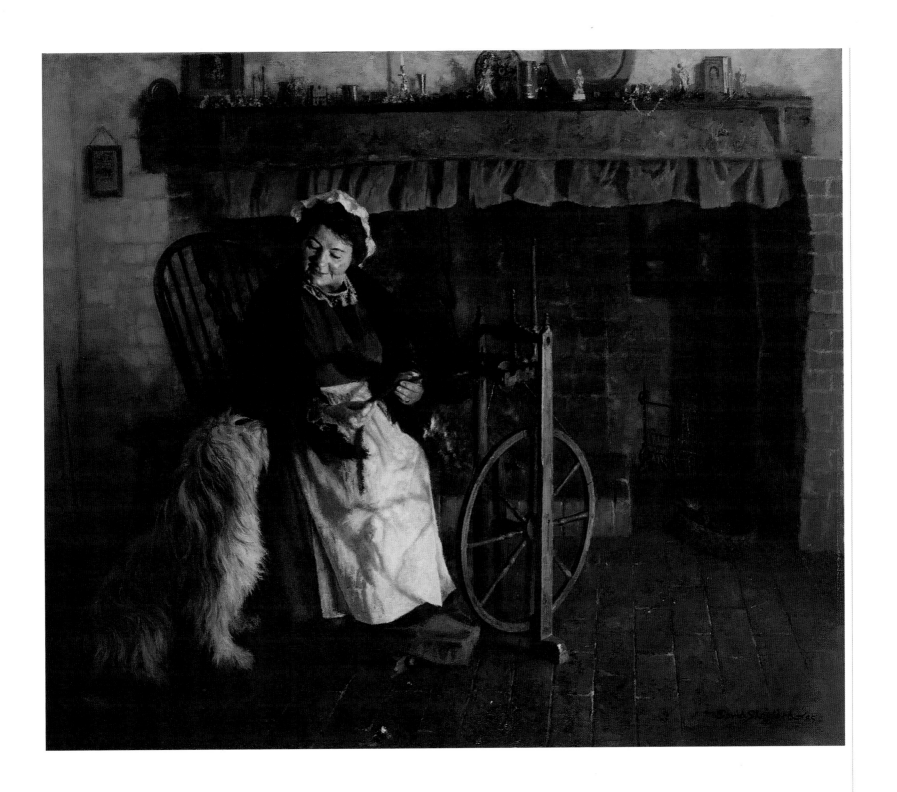

Cottage Companions
Oil on canvas
61 × 71 cm (24 × 28 in)

EVERY PICTURE TELLS A STORY

I don't normally allow myself to have favourite paintings because I believe I have to try to make each painting better than the one before. But I have to confess to a particular affection for *Playtime*.

When you paint a Victorian scene, all the elements in the painting must be from the same period. In order to create the scene here, I went to a theatrical costumiers in Fulham for the clothes and, while I was in the shop, spotted some teddies on the shelf. They only had one Victorian teddy and they never hired him out because he was so valuable. I managed to persuade the two ladies who ran the shop, however, to change their minds, and he was carefully wrapped in bubble wrap. These little human touches all help to make a painting 'go'.

My daughter Mandy found the three children featured when she was at Brighton Art College. The mother spent the whole afternoon putting the little girl's hair in ringlets, and she had this gorgeous old genuine bisque doll. We dressed up a little boy, and put in our own bearded collie puppies. The whole scene was set up in the stable with straw on the floor. It was a nightmare getting it to work – we used kindness, and lots of chocolate. You can't ask children to sit still for five days so you have to work from photographs.

Enthusiasm for the subject is the common denominator in any painting and you have to be sensitive to the subjects and their setting.

How could you resist those children and the puppies? It's sentimental, but there just isn't enough of that these days.

A CLOSER LOOK

The fabric is soft and fluid, so it makes sense to express it with paint that has been well thinned with linseed oil and applied in soft strokes. The same applies to fine silky hair. Thick paint just wouldn't be appropriate.

The narrative element of the painting involves a boisterous romp in a stable and at first glance there are puppies and children all over the place. If you look more carefully, however, the composition is actually carefully considered. Each child is focusing on one or more of the puppies, and the eye contact between the girl and the little dog on the left draws the viewer in, inviting them to share the moment.

The coarse-textured straw in the foreground is painted in highly textured neat paint, applied with a splayed brush to give the impression of clearly defined individual stalks. It's so thick, you can actually feel it with your finger.

Playtime
Oil on canvas
61 × 91 cm (24 × 36 in)

HANDLING WHITES

I believe the dynamic contrasts you can get in oil colour make it a much more exciting medium than watercolour. The challenge I faced when painting *The Curio Shop* from life was to capture the sun glinting against the brass and the copper in the window, and to maintain a balance of contrast between the light and dark areas.

When the painting is finished, you want your brightest highlights to sing out from the surface. That will only happen with judicious use of pure white paint. It's a question of painting in tones and achieving a balance, saving pure white for only the very brightest highlights.

A cloud, for example, may look white, but if you compare it to the bright white of clean sunlit paper it will seem more of a dirty yellow. If you were to paint it in pure white, you wouldn't have any options left when it came to making brighter highlights elsewhere.

There are a number of different whites available in oil colour, but I only use Titanium White, the strongest, most opaque white. Some artists use Zinc White for mixing paler tints, but I can't see the point of it. To me it's a grubby yellowish white. I'd rather start with the purest white and make my own adjustments.

David says...

When you are adding highlights, you can't go whiter than Titanium White, straight from the tube. The ultimate challenge when balancing white tones is to paint the white of an egg on a white saucer on a white tablecloth. Why not give it a go?

The base colour for these sunlit contours is Titanium White, warmed with hot shades of yellow and orange. Starting with white and adding colour to it will give you more control when mixing your paint.

I used Titanium White widely throughout the painting as a base colour for mixing subtle tints, but reserved its pure form for the brightest highlight – the long sliver of reflected light which runs down the length of the hunting horn.

The cool grey of the steps and pavement is a counter-balance against the glistening brass and copper and overall warmth of the shop window, providing a quiet area in the painting as a respite for the eye.

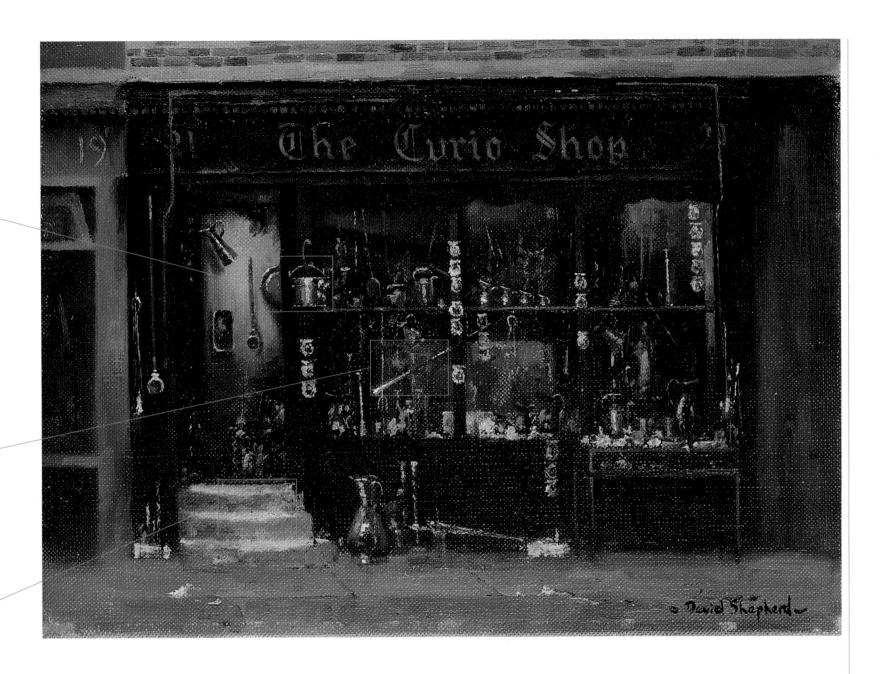

The Old Curio Shop

Oil on canvas
19 × 27 cm (7½ × 10½ in)

I set my easel up near Piccadilly Circus to paint this shop, in the early days of my career when I had the time to paint from life. The painting now hangs in the shop!

LEADING THE EYE

Artists have it in their power to decide on the story they want to tell, and to use the elements within the painting to create a harmonious composition. The artist's skill lies in gently guiding the person looking at the picture towards the main point of interest, without them realizing it.

Lighting your main subject, as in *The Old Forge*, is the simplest way to draw attention to the focal point, but there are other more subtle compositional devices available as well.

The main point of interest in *The Old Forge* is obviously the blacksmith shoeing the horse, with the strongest light on this figure. The rest of the composition, however, must always draw the eye back to him. Seen diagrammatically, it forms a wave that takes the eye up and around the painting in a circular motion, leading it to the focal point.

The chicken in the bottom left is not there by accident. It's carefully placed as a starting point for the eye to move diagonally across the composition, through the anvil and along the curve of the man's back.

The line of the dog's back creates another route up to the body of the figure to the main action – the shoeing of the horse.

From the bottom right-hand corner of the painting, the eye catches the white hairs of the fetlock, just above the horse's hoof, then moves up through the bright white highlighting the edge of its leg.

The glowing highlights on the side of the body carry the eye along the length of the horse before it finally travels down through the white blaze on the horse's face. It took quite a long time and a great deal of patience shaking endless buckets of feed before Princess obligingly turned her head.

Old Ben's Cottage
Oil on canvas
18 × 25 cm (7 × 10 in)

As an artist you have to 'eat and sleep' painting. When I'm driving, I'm always on the lookout for possible subject matter. When I saw this cottage, I had to pull off the road and take numerous photos from different angles.

Personalizing subjects with names gives the viewer a greater sense of connection to the subject. *Old Ben's Cottage*, for example, is much more evocative than *Cow in Front of House*. Even though we don't see Old Ben in the painting, we can imagine him living there.

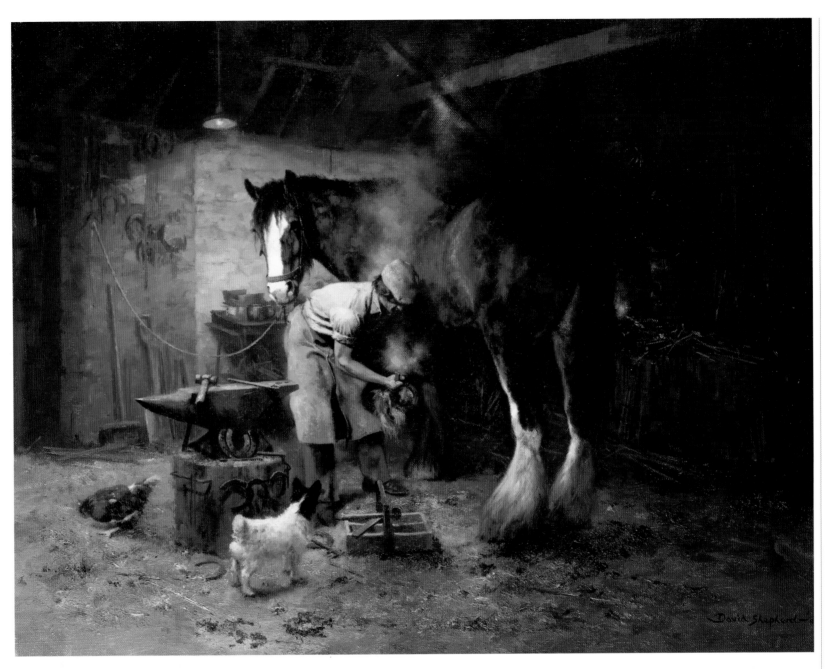

The Old Forge

Oil on canvas
51 × 66 cm (20 × 26 in)

The Old Forge

(diagrammatic version)

This demonstrates how the eye moves
around the painting and focuses on the
point of interest.

PAINTING PORTRAITS

UNDER THE SKIN

If I had the freedom to paint the portraits I wanted to paint, without the constraints of commissions, I wouldn't choose a young debutante. I don't think anyone under 20 years old justifies the effort put in by the painter and the sitter. They haven't lived enough. In my opinion, a portrait of a young person is a camera subject.

Given the choice, I'd go to a market in Marrakech and pick out a wizened old lady whose life and suffering is etched in her face. That's why I painted Rambo, the old fisherman. He had all his life, the salt, the sea and the fishing, in his face. In short, maturity.

I prefer portraits that get under the skin of the subject. If you look at the portraits of the Queen, she's always wearing her diamonds and looking so regal. If only someone could paint her as a normal woman in a skirt and sweater, it would be much better. Instead you get enormous canvases full of Britannia and all the rest, but they don't portray the woman herself.

It's torture to sit for a portrait and, if you're not careful, it shows. Robin Goodwin once sat me in silk robes for five days as a body double when he was painting a portrait of a university chancellor. You don't realize how hard it is until you've done it. Every move alters the folds of the fabric so the sitter has to sit very still.

There are many ways to light a subject. The intensity of the lighting, whether bright and strong or soft and diffused affects the mood of the painting and dictates the clarity and definition of the features.

When you're painting a formal commissioned portrait, the client usually wants a conventional front-lit full face, which leaves little scope for artistic freedom. Out of choice, I prefer to use side lighting to emphasize facial features and create dramatic contrast between the warm shaded area and the higher tones of the lit area. No one did it better than Rembrandt with his powerful side-lit portraits, full of colour and muted low tones.

I painted Rambo from life in Cornwall as he sat on a bench in the sunshine, outside an ancient barn built of brick and stone. The subtle colours and textures of the two surfaces provided a complementary background, painted without any detail that might compete with the figure. In some areas, the Raw Umber washes are so thin that they are little more than a stain.

The face is shown in three-quarter profile, lit by the sun from the right to create warm soft shadow on the other side – and a glint in his eye. If I painted this again, I would darken the background to create a sharper contrast between the cool of the stone wall and the warmth of the shaded side of the face.

It was lucky that Rambo smoked a pipe because the highlight on the silver barrel and the plume of blue smoke help to bring the portrait to life. The painting wouldn't have had half the character without it. Sucking on a pipe creates subtle changes in the contours of the mouth and chin, which have to be carefully observed for authenticity.

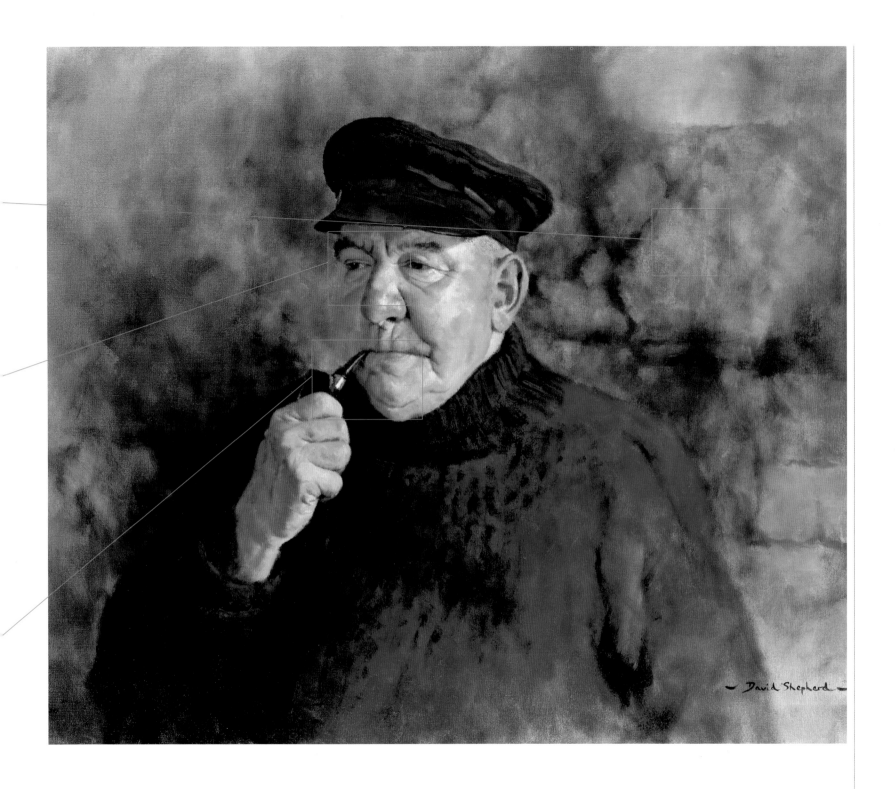

previous spread
Mr Thomas and Major Richard Leveson-Gower
Oil on canvas
119 × 193 cm (47 × 76 in)

Rambo from Life
Oil on canvas
66 × 89 cm (26 × 35 in)

MIXING FLESH COLOURS

Many years ago I bought a new ready-mixed tube of oil colour called Flesh Colour, thinking it would be useful in portraiture. When I squeezed it out on my arm, it was nothing like the true colour of flesh. It looked more like ointment from a tube of Germolene!

Portrait painting calls for the greatest subtlety in colour and tone. Achieving true flesh tones requires all your powers of refinement when you are colour mixing.

Skin tones also alter quite markedly with changes in the light, so it's important to keep it consistent, whether you're working under artificial light or daylight. In studio conditions, north light is ideal. Outside, it's best to choose a settled day, with either a cloudless sky for constant sunshine, or completely overcast with little variation. The worst day for outdoor portrait painting would be one with blue sky and cloud, with the sun coming out and going in all the time.

A basic colour for flesh tone might start with Yellow Ochre and Crimson Alizarin, mixed with Titanium White to give it depth. This will inevitably need adjusting according to the complexion of the subject as well as the tonal variations between light and shaded areas. A touch of Ivory Black mixed with Light Red or more Crimson Alizarin will lower the tone. If it's still too hot, try cooling it further with a trace of Cobalt Blue.

When you're experimenting with mixing flesh tones, it's a useful exercise to paint a little onto your hand or arm to check how closely it matches true skin colour. Make notes as you go along, which will provide a useful point of reference later when you're working with a live sitter. They probably wouldn't take kindly to being daubed with oil paint!

I'd always recommend mixing colours directly on the canvas rather than on your palette. If you do so, it will allow one colour to glow through another and you'll get interesting textured effects in your work.

Avril
Oil on canvas
76 × 56 cm (30 × 22 in)

The only time my wife Avril has sat still long enough for me to paint her portrait was years ago when she was confined to bed with mumps. As you can imagine, the result wasn't very flattering so it has stayed in the attic. I painted this portrait from photographs, but secretly I prefer the other one. Nothing beats a portrait painted from life.

Dreaming
Oil on canvas
61 x 45 cm (24 × 18 in)

This portrait of my daughter Mandy in late Victorian dress presented a number of challenges. The sunlight coming from the left is very bright, and it required a careful balance of colours and tones to flood both the scene and the subject itself with light. The halo effect of the sunshine through Mandy's hair is a key element in conveying the intensity of the sunlight.

IS EVERY PORTRAIT A SUCCESS?

If a painting is going badly I don't just chuck it in the bin. That's a waste of canvas and paint. This half-finished painting of a shepherd feeding a lamb isn't working so far. The lamb is in the wrong position and its legs are hanging all over the place. My grandchild Peanut is supposed to be looking up at the shepherd, but instead she's looking behind him, diverting the viewer's attention from the main subject and weakening the narrative impact.

I can't see a way to resolve the problem here, except to paint her out and start again. Or, I could literally cut out that part of the canvas, join it to a fresh piece and create a new centre of interest for her to look at.

As I mentioned earlier, rushing in with more enthusiasm than planning is a failing of mine. I get carried away painting the main subject, then realize that it is in the wrong place. There are only two solutions – wipe away or paint over what you have done or get the canvas cut and joined. The latter is an expensive option.

A little more time spent on positioning and planning will save you a lot of frustration and wasted effort later. I'd recommend that you do as I say, not as I do in this instance!

**Old Man Feeding Lamb
(unfinished)**
Oil on canvas
61 × 51 cm (24 × 20 in)

David says...

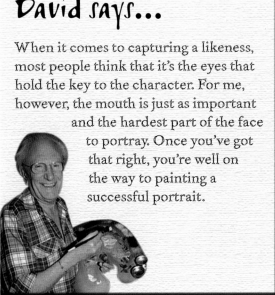

When it comes to capturing a likeness, most people think that it's the eyes that hold the key to the character. For me, however, the mouth is just as important and the hardest part of the face to portray. Once you've got that right, you're well on the way to painting a successful portrait.

Jesus (detail from Christ on the Battlefield)
Oil on canvas
6 x 2 m (20 x 8 ft)

If I am remembered at all, it will probably be for my elephants but, given the choice, I would prefer it to be for this painting. It was commissioned by the army chaplains for a reredos to hang behind the altar in a proposed army garrison church at Bordon Camp in Hampshire. The full-length painting was 20 foot (6 m) wide, with a life-size figure of Christ in the middle.

The whole portrait had to be painted in one gruelling six-and-a-half-hour session. As with all portraits, the sitter had to keep absolutely still. If he moved, all the folds in the costume would have looked different, so the poor model was like stone by the end.

PAINTING FABRICS

Over the years I've painted four portraits of headmasters at Stowe. My parents sent me to school there as they assumed that the Luftwaffe would never fly north of Watford. I'd only been there for a few weeks when a whole load of bombs was dropped across the playing fields!

The great beauty of Stowe was bound to brush off on anyone with artistic inclinations, however latent, and it certainly shaped my future life far more than I could then know. Art for me was born at Stowe, but for the wrong reasons – anything was better than the torture of playing rugger. The more artistic among us donned yellow waistcoats and went faintly Bohemian on Thursday afternoons. It was here that I painted my very first oil painting – the lamentable birds on plasterboard that ensured my rejection by the Slade School of Art (see page 10).

I painted Donald Crichton-Miller, former headmaster of Stowe, from life, over the course of five days in the 1960s. The other two shown here I painted from photographs. In each portrait I try to capture the essential character of the man and his particular interests.

The clothes that a subject chooses to wear for a portrait help to indicate both character and status. Capturing the intrinsic qualities of different fabrics depends on the forms the material makes as it drapes and folds and the way it responds to light.

Folds in thin fabrics such as silk are characterized by sharp, well-defined edges and pronounced tonal contrast between light and shaded areas. Recreating a highly reflective shiny surface requires bright highlighting along the edge of the fold and deep warm tones in the shaded creases. Thicker materials, such as tweed, form rounder, less pronounced folds, and the tonal contrasts in matt, non-reflective surfaces are much softer.

Painting subjects in context is an important aspect of portraiture. When a setting includes a background or objects that are important to the subject, it helps to tell his or her story.

Donald Crichton-Miller
Oil on canvas
82.5 × 70 cm (32½ × 27½ in)

Bob Drayson
Oil on canvas
77 × 70 cm (30¼ × 27½ in)

Christopher Turner
Oil on canvas
76 × 60 cm (30 × 23½ in)

To be headmaster of a major public school you have to be an astute businessman, but Christopher Turner was also an aesthete and very informal. His choice of a soft tweed suit, rather than the more traditional academic gown, helps to convey the character of the man.

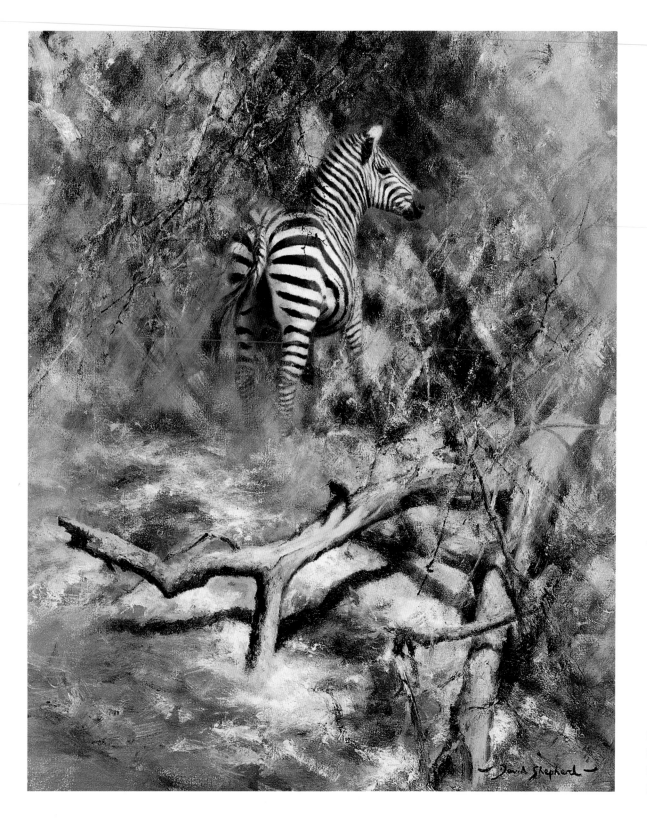

left
After the Burning
Oil on canvas
76 × 63.5 cm (30 × 25 in)

right
Savuti Waterhole
Oil on canvas
58.5 × 117 cm (23 × 46 in)

GALLERY

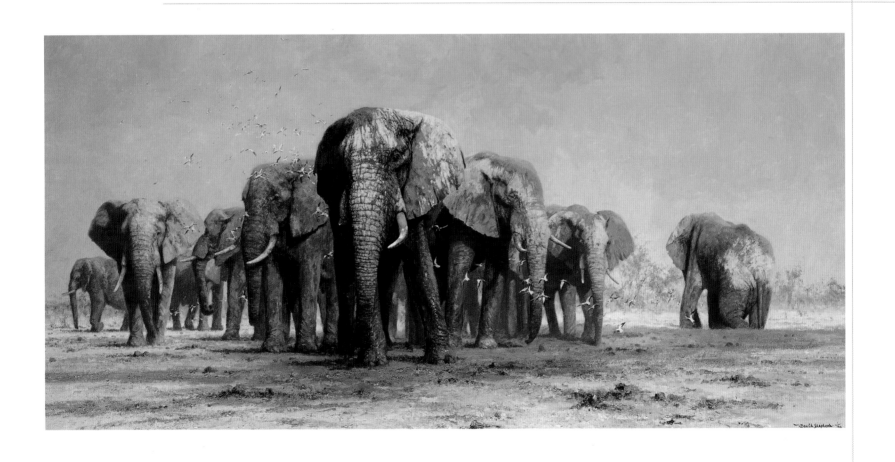

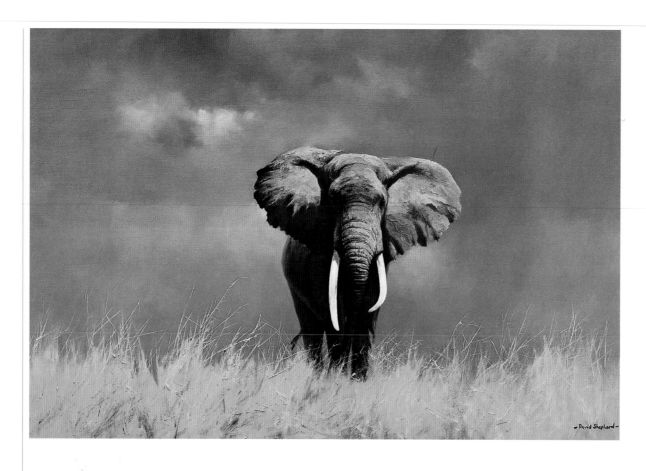

Wise Old Elephant
Oil on canvas
51 × 76 cm (20 × 30 in)

This launched my wildlife painting career in 1960.

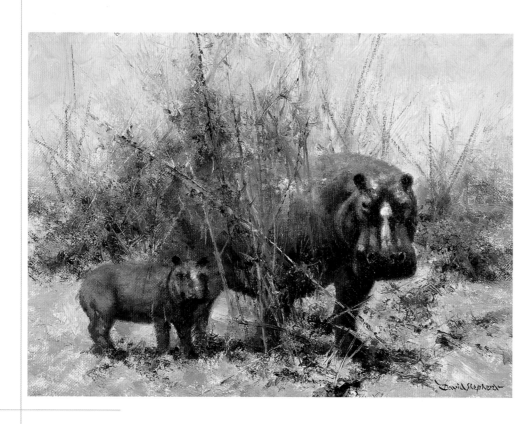

Hippo and Calf
Oil on canvas
20 × 25.5 cm (8 × 10 in)

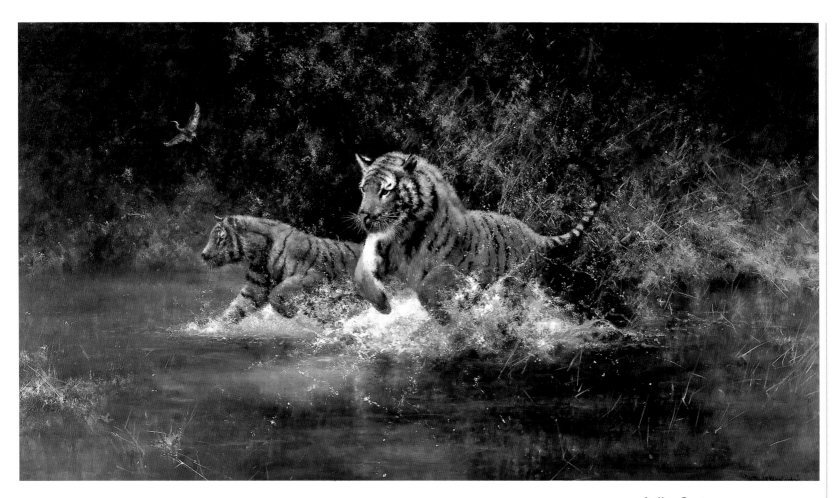

Indian Summer
Oil on canvas
71 × 127 cm (28 × 50 in)

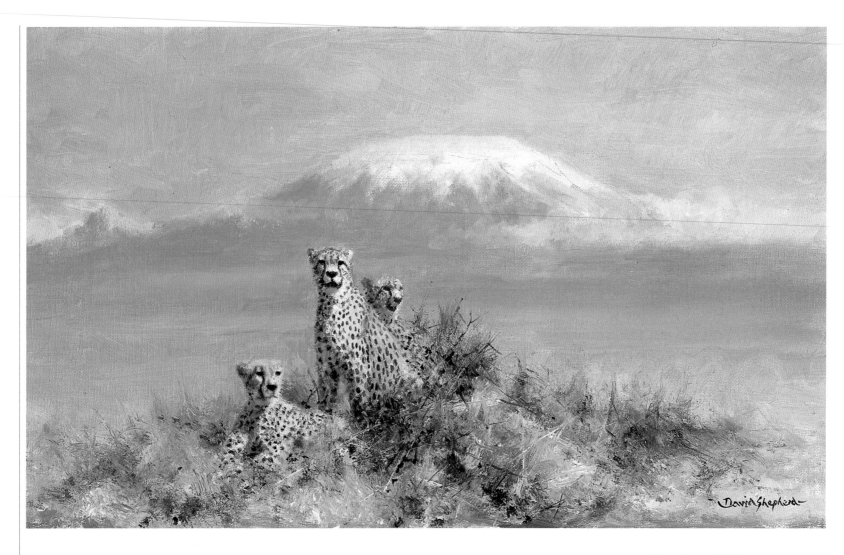

Cheetahs and Kilimanjaro
Oil on canvas
25.5 × 45 cm (10 × 18 in)

Lioness and Cubs
Oil on canvas
61 × 92 cm (24 × 36 in)

Elk in Banff National Park
Oil on canvas
56 × 96.5 cm (22 × 38 in)

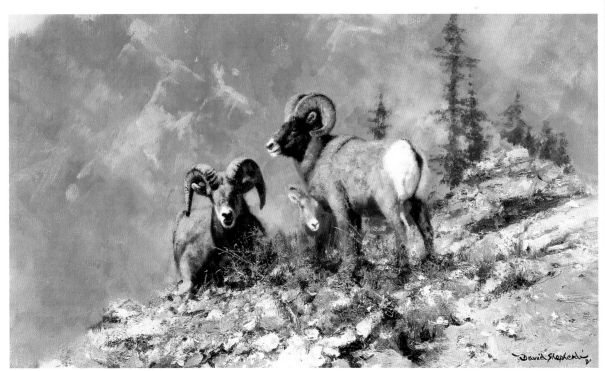

Big Horn Sheep
Oil on canvas
51 × 71 cm (20 × 28 in)

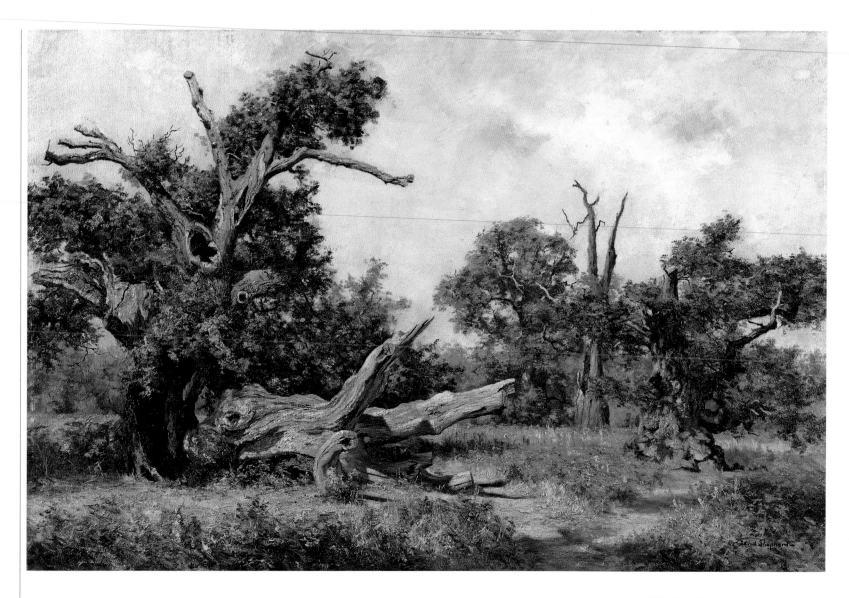

Windsor Oaks
Oil on canvas
61 × 91.5 cm (24 × 36 in)

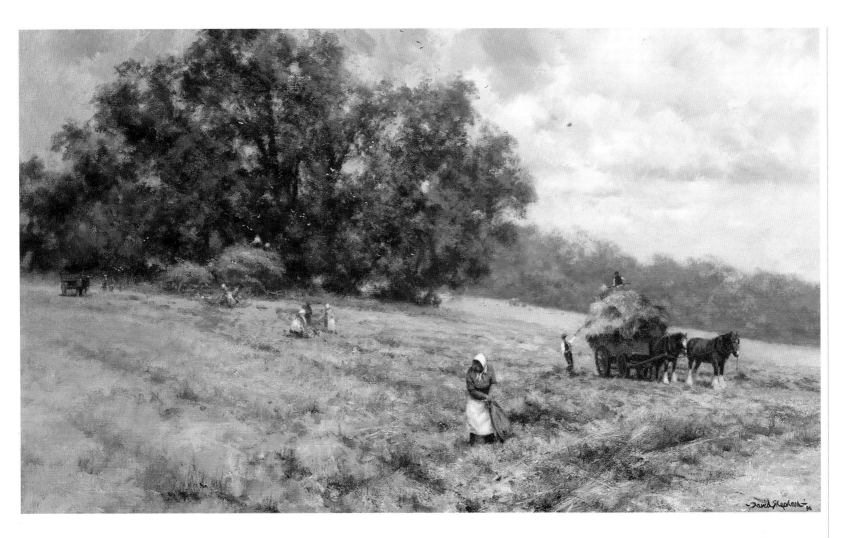

Summertime
Oil on canvas
45 × 76 cm (18 × 30 in)

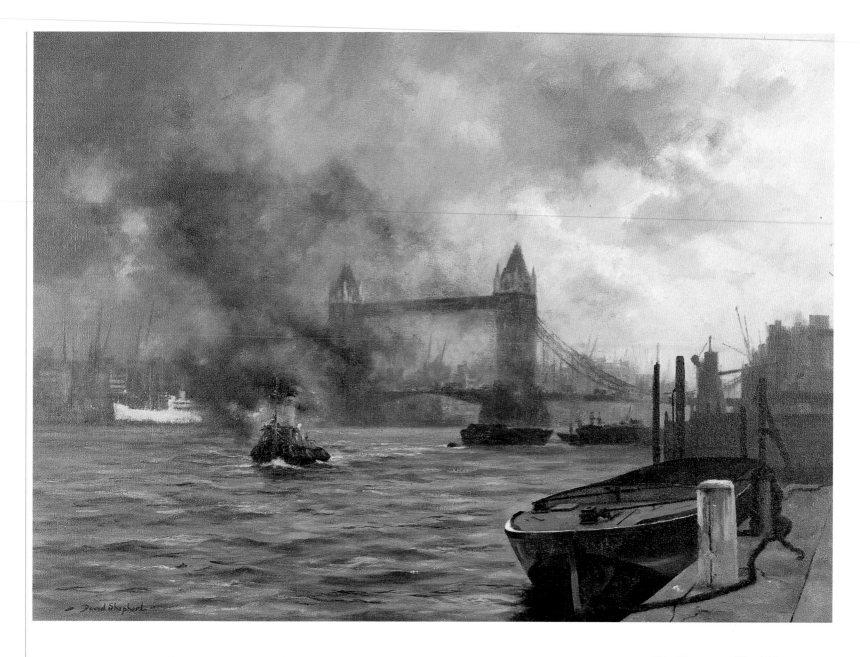

The Thames at Blackfriars, 1960
Oil on canvas
56 × 76 cm (22 × 30 in)

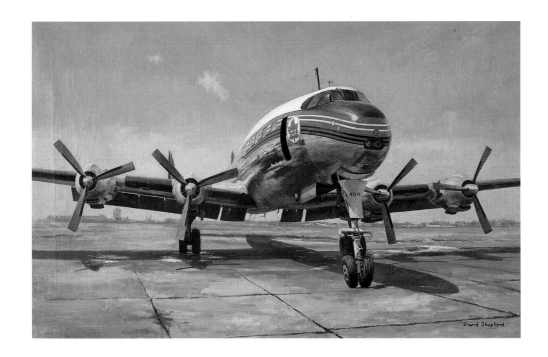

**Super Constellation,
Trans Canada Airlines**
Oil on canvas
51 × 76 cm (20 × 30 in)

**City of Germiston and the
Johannesburg Gold Tips**
Oil on canvas
51 × 86 cm (20 × 34 in)

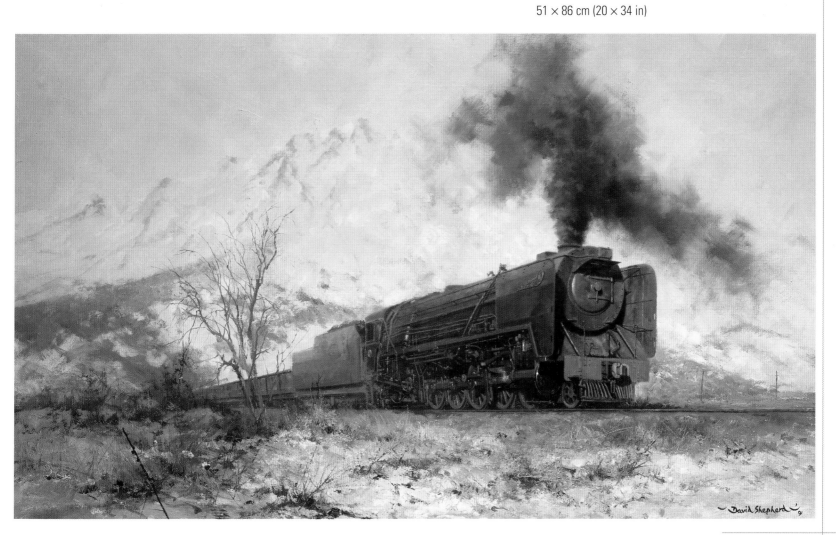

INDEX

Painting with David Shepherd